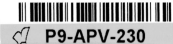 

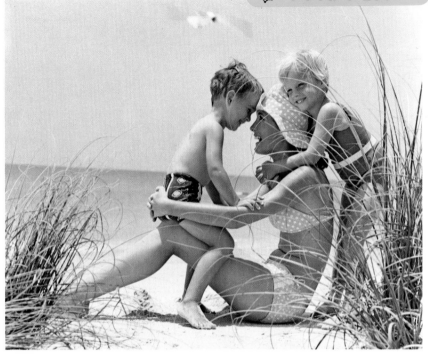

# AMATEUR SOUND MOVIES – A NEW DIMENSION

For years a favorite theme of science fiction writers has been "the time machine." In the stories, people climb into a piece of apparatus that whisks them back and forth in time. This is a great concept for the writers, and while we can't be sure that it's impossible, it's likely that we'll never achieve this dream except through memory and imagination.

Memory and imagination are fine, but they tend to be a little fuzzy and lacking in detail. This book will show you how you can recall the past with your own "time machine": concisely, colorfully, and *easily* through the *near magic* of color sound movies.

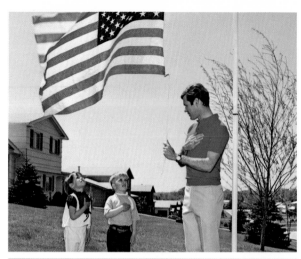

Normal movie exposures produce some blurring of the image in individual frames, so most enlargements of movie frames are not suitable for reproduction. For this reason, the illustrations in this book are made from larger-format, still photographs taken under conditions similar to those you might experience in making movies.

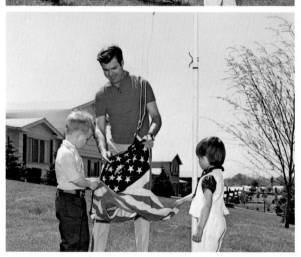

# CONTENTS

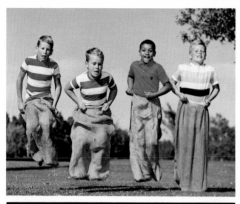

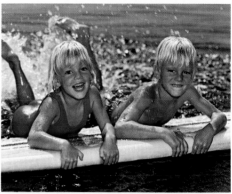

# SOUND MOVIES ARE FUN!

They really are! When you get that first roll of sound film back from processing and discover the interest and enjoyment that sound adds to your movies, you'll be delighted! What a treasure those movies will be in the years to come!

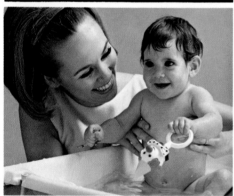

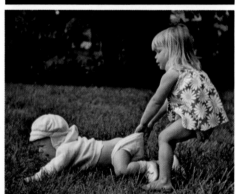

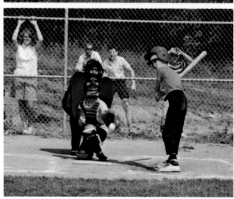

4

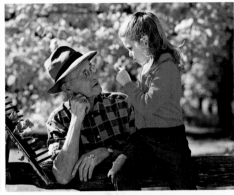

The growing family provides interesting subjects for sound movies that increase in value, year after year.

Picturing family fun in color and with sound can bring back much of the original enjoyment at each showing.

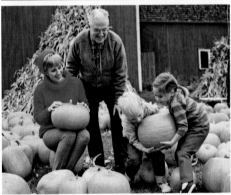

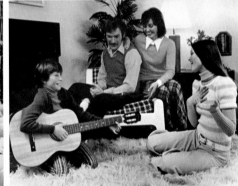

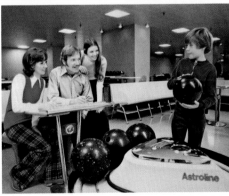

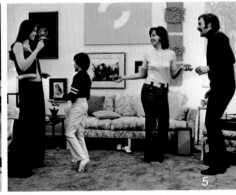

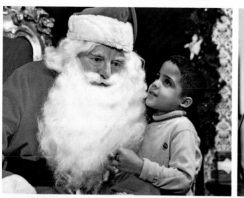

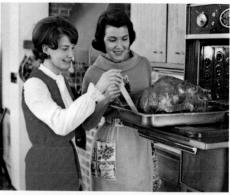

Holiday-fun movies help you relive some of the most memorable events of your life.

Parties, whether they're special occasions or spur-of-the-moment affairs, offer excellent sound-movie possibilities.

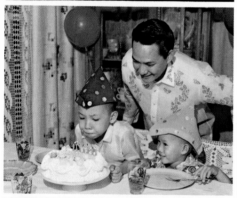

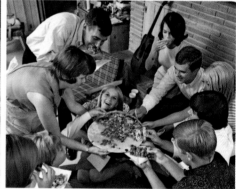

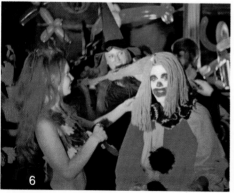

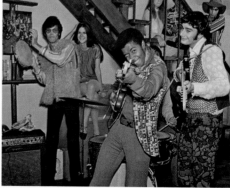

Vacation movies depicting colorful sound-filled scenes of people, places, and events will be appreciated long after vacation is over.

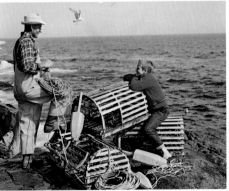

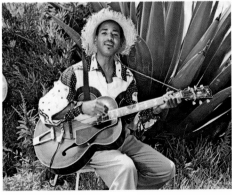

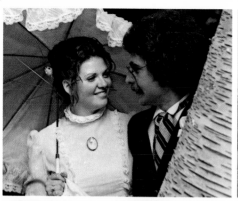
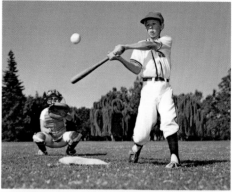

Weddings, graduations, and movies of other special events can give you much pleasure. Just think how much more satisfying they'll be with sound!

The excitement of sporting events will come across more vividly with sound movies.

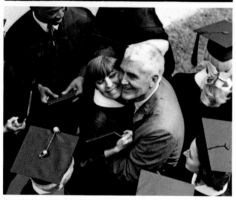
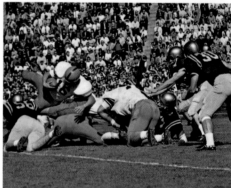

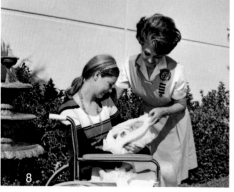

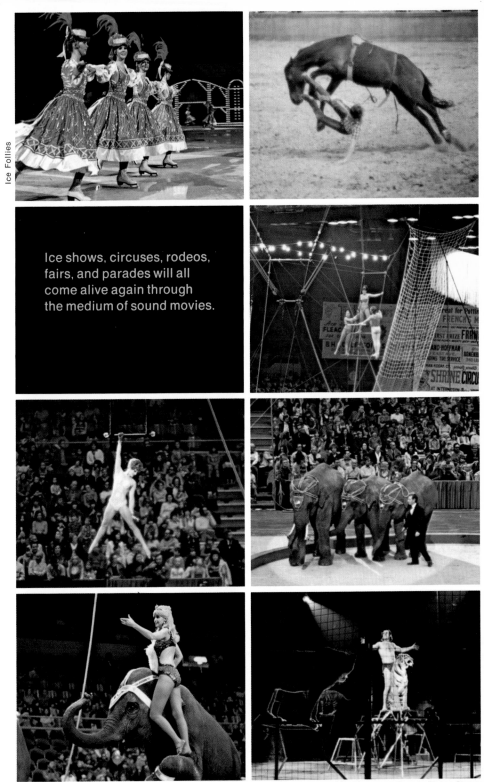

Ice Follies

Ice shows, circuses, rodeos, fairs, and parades will all come alive again through the medium of sound movies.

Circus pictures on this page are of the Damascus Temple Shrine Circus

*Hear* as well as *see* the action when you project your sound movies of plays, recitals, and other similar events.

Be of service! Make sound movies of youth and community activities.

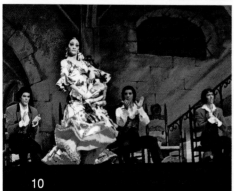

José Molina "Bailes Españoles" (Spanish Dances)

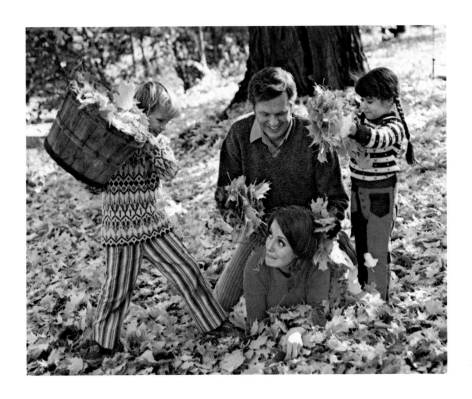

Other possible subjects for sound movies are highlights from special shows or events on television (providing they aren't copyrighted), religious events or ceremonies, conventions, rallies, and documentation of noise-pollution problems. You can probably think of many more, suited to your own activities. The sound movies you make can either serve an immediate need or provide enjoyment and bring back pleasant memories for many years to come. In the few moments that it takes to set up a projector and screen you can enter your own private "time machine" and relive Todd's first haircut, Lisa's first steps and her squeals of delight at her accomplishment, the family reunion at cousin Jean's house, or that wonderful vacation trip to colonial Williamsburg. Isn't it great fun to be a time traveler?

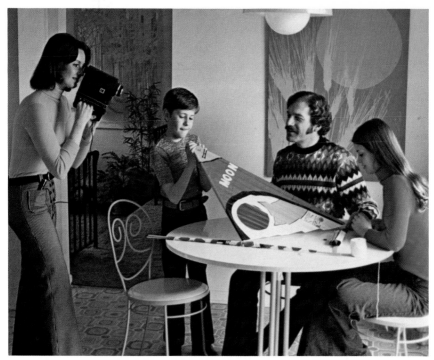
From making to viewing—sound movies are fun!

# SOUND MOVIES—A NEW BALL GAME FOR MOVIE-MAKERS

Amateur movie-makers have long enjoyed a special advantage in taking pictures of people, places, and events —the ability to show their subjects in an animated state. Instead of capturing a split second in time and space, they have been able to catch a full range of varying facial expressions, movements, and constantly changing events. What's more, they've been able to do it in beautiful color, which enhances the realistic effect of living and moving subjects.

All that remained to bring the original scene close to reality was the addition of sound that would synchronize with the action as it took place. Now you can add this new dimension to your home movies with movie cameras that record the sounds as well as the scene and projectors that reproduce those sounds in synchronization with the movies, such as the KODAK EKTASOUND 130, 140, 150, and 160 Movie Cameras and the KODAK EKTASOUND 235B and 245B Sound Projectors. *These cameras and projectors will allow you to photograph, record, and play back scenes almost as faithfully as they initially were seen and heard.*

It's a completely new ball game, so let's lay the ground rules that will let you take full advantage of your expanded opportunities for picturing the important things of life as they happened—in color—in motion—*and with sound!*

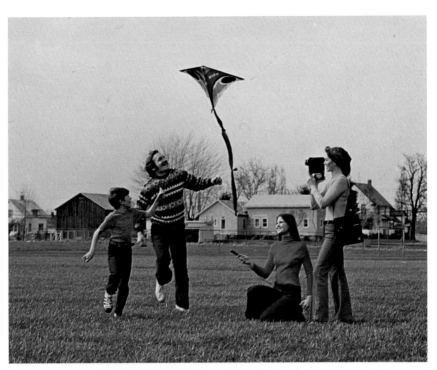

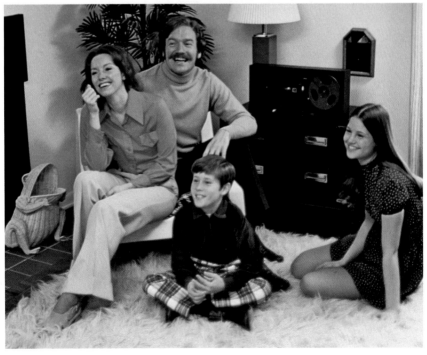

13

# SOUND MOVIES ARE EASY!

Movies with sound are almost as easy to make as super 8 silent movies—just plug the microphone into a KODAK EKTASOUND Camera and start taking pictures.

The camera is only slightly more complex than a silent movie camera. It has two drive motors (one for film advance and exposure—another for the sound-recording mechanism) and a transistor amplifier with batteries for power, all wrapped up in a relatively compact and lightweight body. The optical and exposure-control systems are the same as those used on the popular and proven KODAK XL Movie Cameras. This means that you can take pictures in low-light levels that weren't possible before; but what's best is that you can do it while simultaneously recording the sound that is present at the scene.

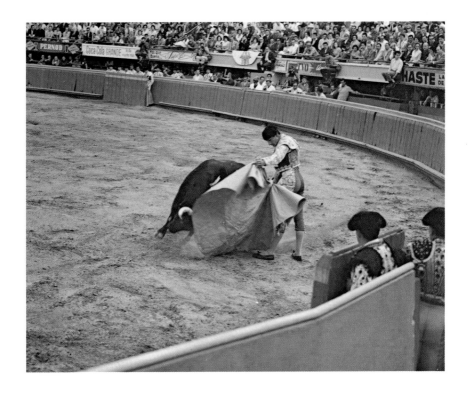

# EQUIPMENT

If you are interested in making and projecting single-system sound movies, there is a variety of cameras and projectors available. Not every model of sound camera has the capacity for existing-light movies. However, KODAK EKTASOUND Movie Cameras feature both single-system sound *and* existing-light capability *in all models*. Here are brief descriptions of the available KODAK EKTASOUND Movie Cameras and Movie Projectors.

### The KODAK EKTASOUND 130 Movie Camera

The photographic features of this camera are similar to the KODAK XL330 Movie Camera—with the addition of synchronized sound. A fast fixed-focus six-element, 9 mm $f/1.2$ KODAK EKTAR Lens, CdS double-vane exposure control, and 230-degree shutter let you make acceptable sound movies with as little as seven foot-candles of illumination (with KODAK EKTACHROME 160 Sound Movie Film).

A built-in amplifier with automatic gain control (AGC) records voice and music at a camera speed of 18 frames per second. An omnidirectional microphone is used that matches the amplifier impedance of 200 to 600 ohms. For additional information on microphones, see page 36.

### The KODAK EKTASOUND 140 Movie Camera

The EKTASOUND 140 Movie Camera has the same features as the 130 Movie Camera, plus a focusing ten-element, 9 to 21 mm $f/1.2$ KODAK EKTAR Zoom Lens and a sports-type viewfinder. A zoom control lever (or the knurled ring) on the lens can be used to change the focal length of the lens and control the speed of the zoom.

### The KODAK EKTASOUND 150 Movie Camera

The EKTASOUND 150 Movie Camera includes the features of the 140 Movie Camera, plus a zoom lens with a choice of power *or* manual zoom control.

### The KODAK EKTASOUND 160 Movie Camera

The EKTASOUND 160 Movie Camera has the same features as the 150 Movie Camera, plus a coupled range-finder.

*All EKTASOUND Movie Cameras accept either sound- or silent-film cartridges.*

## KODAK EKTASOUND
### Camera Battery Pack

Under continuous use or in cold-weather operation (below 32°F), the life of batteries is considerably reduced.

The KODAK EKTASOUND Camera Battery Pack holds six AA-size *alkaline* batteries and can be used to augment the power of the motor batteries during extended use or cold-weather applications.

### KODAK Power-Charger Unit

Consisting of a rechargeable power pack and a charger, this unit is used to supplement the motor-drive batteries of Kodak sound cameras.

When fully charged, the power pack will allow you to expose up to fifty 50-foot cartridges of sound movies *over a short period of time.* In addition, the power pack can be helpful in extending the life of your camera batteries during cold-weather operation.

The power-pack charger operates from a 120-volt, 60 Hz power outlet and can bring the power pack to a full charge overnight.

### The KODAK EKTASOUND 235B Movie Projector

This projector, equipped for playback only, features channel threading, sprocketless film drive, two-way projection (to front *or* rear), fast forward and rewind, bright illumination, auto-matic stop at the end of the film, lamp On/Off switch, room-light receptacle, permanently attached power cord, and unique bookshelf styling. You have a choice of an *f*/1.5, 22 mm lens or an *f*/1.3, 15 to 30 mm zoom lens. The optical system offers excellent edge-to-edge image sharpness.

### The KODAK EKTASOUND 245B Movie Projector

In addition to the features of the EKTASOUND 235B Movie Projector, the 245B Projector offers *record* as well as playback capability, sound-on-sound recording, automatic *or* manual gain control, a VU meter, and a safety interlock to prevent accidental erasure of the sound track. The versatility of this projector will give you many hours of watching *and* listening enjoyment.

For additional information on these and other Kodak products, see your photo dealer.

### The Instruction Manual

Before we leave our brief discussion of Kodak sound cameras and projectors that are available, we'd like to say a few words about that oft-forgotten friend, the instruction manual. Your manual tells you how to get the most out of your equipment. Please study it carefully. You'll be happy you did when you see *and hear* the good results.

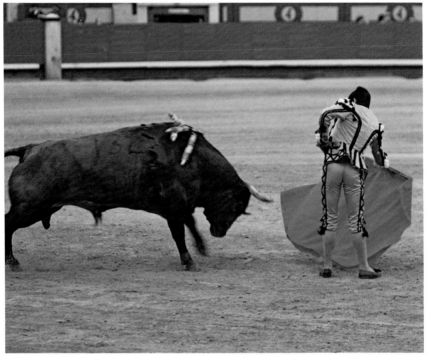
Kodak sound movie films help you capture all the excitement of unusual events.

# FILMS

### KODAK EKTACHROME 160
### Sound Movie Film (Type A)

This film with a speed of ASA 160 will produce pictures in low-light or daylight situations.

Two magnetic stripes are coated on the base side of the film during its manufacture. A stripe approximately .027-inch wide is coated on the edge away from the perforations and is used for sound recording. A narrower stripe is placed between the perforations and the right edge of the film to provide uniform winding of the film roll. Thinner film base is used to compensate for the added thickness of the sound and balance stripes; therefore, 50 feet of striped film takes no more space in the cartridge than the same amount of unstriped film. The sound stripe is suitable for recording both voice *and* music.

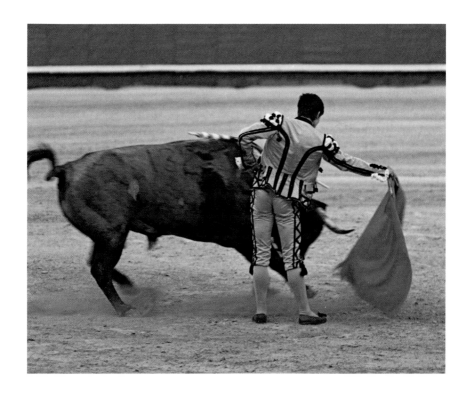

## KODACHROME 40
## Sound Movie Film (Type A)

This film with a speed of ASA 40 provides excellent grain and color characteristics and can be used to make sound movies under normal lighting conditions outdoors. Indoor sound movies require either a relatively high level of illumination or movie lights. The sound-stripe configuration, film base, and cartridge are about the same as for the EKTACHROME 160 Sound Movie Film.

*Sound-film cartridges are larger than silent-film cartridges and can be used only in cameras specifically designed to accept their greater size.*

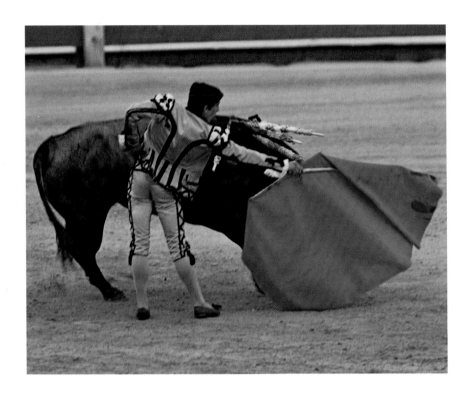

### Silent Films

KODAK EKTASOUND Cameras will accept super 8 silent-film cartridges; so you aren't locked in to the use of sound film. If desired, a sound stripe such as KODAK SONOTRACK Coating can be added to your silent film later; however, the cost is greater than buying prestriped sound film initially.

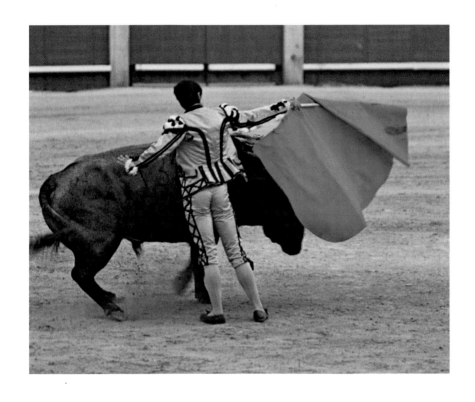

# SPECIAL CONSIDERATIONS
# FOR SOUND MOVIES

Making sound movies involves considerations that don't apply to silent movies. In silent movies, everything is visual. Your prime concerns are subject matter, lighting, color, composition, continuity, and use of the proper film and equipment fitted to your needs. Good composition in your movies requires not only the proper placement of the elements of each setting but also attention to detail and the avoidance of unnecessary, unrelated, and often distracting objects in the scene.

Visual clutter is often created because your eyes focus on the main area of the scene and tend to disregard other objects in the field of view. Those objects aren't of prime importance, so they are rejected by your mind and your eyes. Unfortunately, the camera lens has no mind and can't be selective. Everything it "sees" is recorded on the film; so you have to discipline yourself to be more observant when making movies. Some examples of visual cluttering are power or telephone lines crisscrossing a tranquil scene, a tree or pole seemingly growing out of the head of your subject, and visible trash cans or refuse (unless you're making a movie about littering).

The noise of bowling alleys is a good example of background sounds that can be distracting, especially when you want to record the conversational byplay.

## Audio Cluttering

With sound movies you must consider not only visual clutter but also audio clutter, or the intrusion of unwanted and undesirable sound. Your ears can be as selective as your eyes, concentrating on and picking up only the sounds you're interested in and disregarding other sounds in the background. Microphones, like cameras, are incapable of picking out the important and rejecting the unimportant (for more information on microphones, see page 36). They pick up all of the sound within their sensitivity range, good *and* bad, and the recording mechanism (not having any intelligence) records exactly what it "hears." Several examples of audio clutter are the background sounds of lawn mowers, television and radio sets, traffic, children playing, dogs barking, typewriters, and air-conditioning or heating units.

Exclusion of unwanted background noise is especially important when your camera amplifier features automatic gain control (AGC). The AGC picks up the strongest signal available and adjusts the input volume to an acceptable level. Therefore, if the signal from an undesired sound is strongest, this is the primary sound that will be recorded. At worst, extraneous sound can dominate your recording; at best, it can detract from the sound quality of your movie.

24

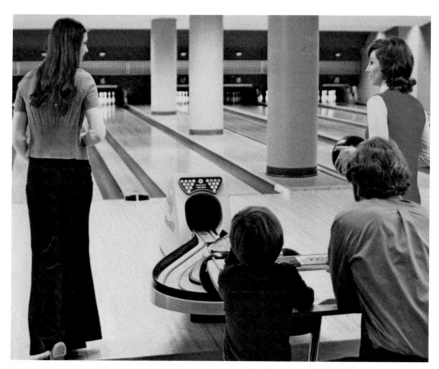

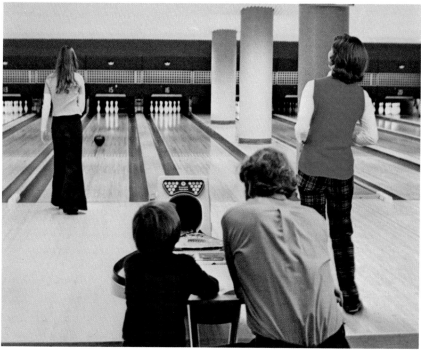

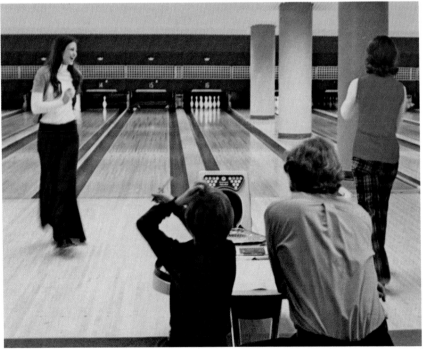

## Microphone Placement

One of the most important factors in recording for sound movies is the proper placement of your microphone. Your recording will only be as good as the quality of the sound input. If you feed in a strong signal, your sound should be good. A weak signal will probably give you poor sound. If you place your mike close to your primary sound source, you should receive a strong signal and have less chance of picking up distortion or unwanted background noise. You'll probably get the *best* results if your mike is no closer than one foot, nor farther than four or five feet, from the main source of sound. However, if the sound is very loud or you can't get close to the source, you may have to place the mike at longer distances.

For more complete information on microphone placement, see the section titled "Microphone Placement, Handling, and Recording," page 39.

## Editing and Splicing

Because of the sound track, editing and splicing procedures for sound movies are somewhat more involved than for silent movies. Detailed information is given in the section titled "EDITING AND SPLICING YOUR SOUND MOVIES," page 86.

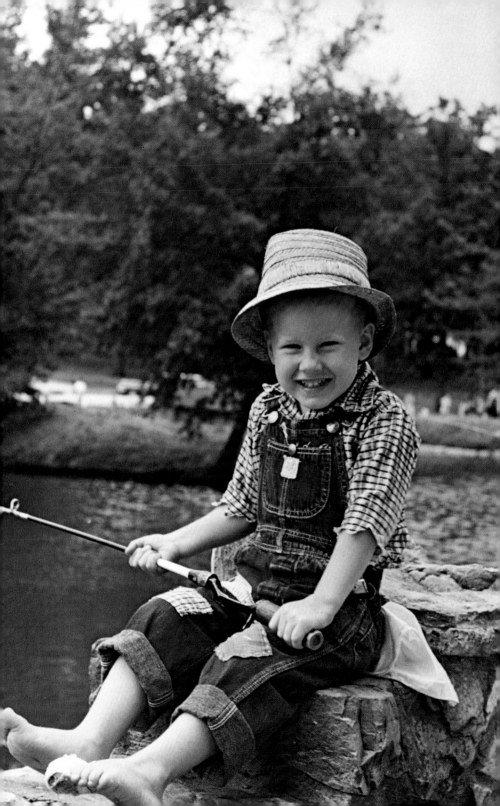

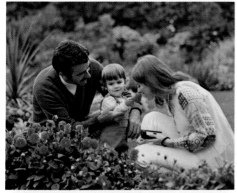

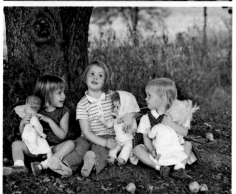

# SPONTANEOUS VS PLANNED SOUND MOVIES

### Spontaneous Sound Movies

There are two features that make cameras such as the KODAK EKTASOUND Movie Camera outstanding! They record synchronized sound as you make your movies and also provide acceptable exposures in almost any light. This combination allows you to make sound movies at the drop of a hat. All you need is a suitable subject and sound!

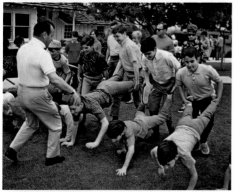

Get away from the restrictive concepts of keeping the camera in an out-of-the-way cupboard or closet and using it only on special occasions. You may get some nice pictures of those special events, but think of all the spontaneous picture opportunities you'll miss in between.

*Be spontaneous—and think sound!* Keep your camera as handy as you might a pack of matches. You won't set the world on fire; but you *will* capture a lot of the day-to-day occurrences of your life that will be priceless as you project your movies in the years to come.

You should have both spontaneous *and* planned sound movies in your film library. You can obtain the best results through careful planning and photography; however, sometimes you'll have to act quickly or miss a once-in-a-lifetime opportunity for some interesting or unusual movies. In such cases, you may have to disregard many of the standard rules, such as microphone placement and attention to detail. Do it! Spontaneity and interest will probably make up for any lack of technical perfection.

## Planned Sound Movies

A little planning and attention to detail can lift your home movies above the "ordinary" category. Completely candid movies are fine; they can bring hours of enjoyment to you and your immediate family. But casual friends and more distant relatives may lose interest in lengthy showings of unrelated and sometimes repetitious scenes.

What's the answer? Add a little plot to your movies! Plan ahead and tie the scenes together so that you have a story. There's no need to plan a Hollywood epic. Just present your movie in a logical and chronological order and have your subjects doing something. At the same time, you should try for added technical excellence through greater attention to the setting, lighting, composition, and microphone placement for good sound quality.

Keep one thing uppermost in your mind when planning your movies— your audience is going to *hear* as well as *see* the results. Trivial chatter will soon cause your audience to lose interest and "tune out;" so have your subjects center their talk around what they're doing. Let the sound reinforce the action.

Make your movies tell a story. Keep them simple, fill them with action and sound. If you put forth a little extra time and effort, the results can be well worthwhile.

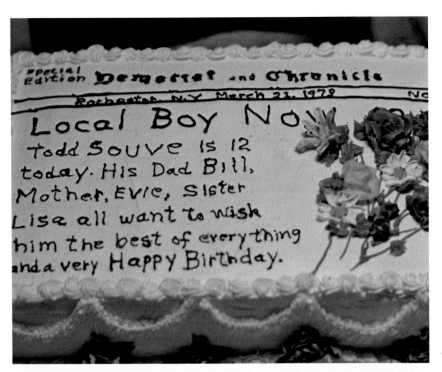

Special
Edition **Demorret** and **Chronicle**

Rochester, N.Y. March 21, 1979          No

Local Boy No

Todd Souve is 12
today. His Dad Bill,
Mother, Evie, Sister
Lisa all want to wish
him the best of everything
and a very Happy Birthday.

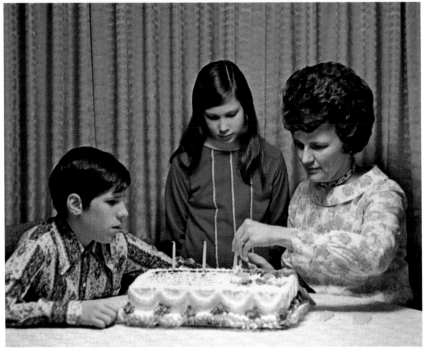

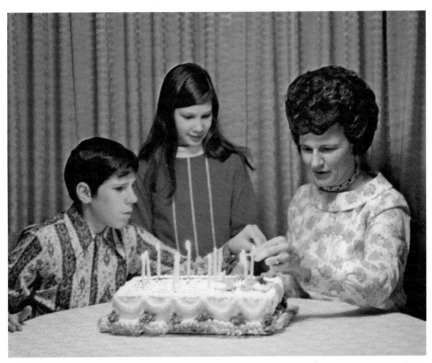

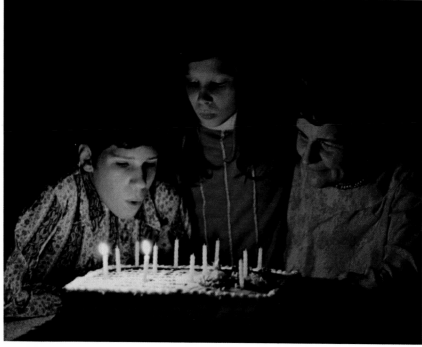

34

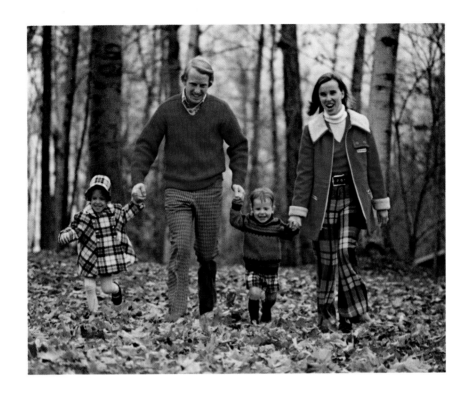

# SOUND-RECORDING TECHNIQUES FOR MOVIES

Recording sound on a movie is basically the same as recording sound on a tape recorder. In fact, that's what you actually have—a miniature tape recorder built into your camera.

There are only a few basic differences between a camera recording system and a tape recorder.

- For use in cameras, the magnetic-oxide coating is placed on a film base in the form of a very narrow sound stripe. For tape recorder use, the coating is on a relatively wide, very thin acetate, Mylar, or polyester tape.

- Sound recorded in the camera is synchronized with the picture.
- There's no erase head in the camera, since the film can be put through the camera only once.

In both cases, sound is picked up by a microphone, converted into electrical impulses, transmitted through an amplifier, and recorded on a magnetic coating. With sound movies, after the film image is developed, all you need is a projector capable of playing back the sound that is recorded and synchronized with the picture.

## Microphones

Briefly stated, a microphone is a device that converts sound waves into electrical impulses. Since all recording of sound is done initially with a microphone, any recorded sound is only as good as the microphone that produced it.

There are several types of microphones used in recording, broadcasting, and sound amplification. They can be classified by the pattern of their sound pickup, such as—

• Unidirectional, which picks up sound primarily from one direction.

• Bidirectional, which picks up sounds on two opposite sides of the microphone.

• Polydirectional, with adjustable pickup areas.

• Omnidirectional, which is capable of picking up sound from all directions.
  The microphone provided with KODAK EKTASOUND Movie Cameras is omnidirectional, and is able to pick up sound from all directions. Most general-purpose mikes are of this type and are especially useful when the sound to be recorded may be coming from a variety of sources. Of course, there are times when you might want to exclude specific sounds. In such cases, you might want to use another type of microphone. If you decide to use a different mike, be sure that its impedance matches that of the amplifier with which it will be used. (Refer to the manufacturer's specifications for this information.)

Although small and relatively inexpensive compared with professional studio mikes, the microphone provided with your camera makes good-quality, lifelike recordings if used properly. Correct use of the microphone is a key to the successful recording of live sound.

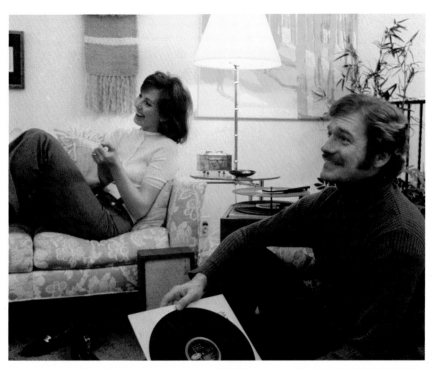

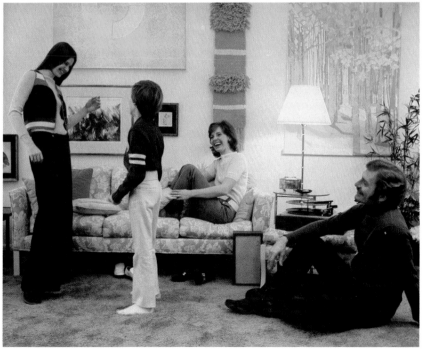

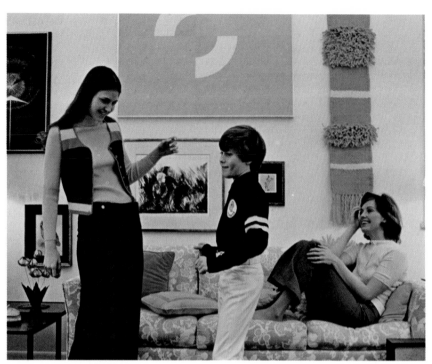

## Microphone Placement, Handling, and Recording

The location of your microphone has a definite effect on the quality of the sound you record. The basic concepts are the same whether you're recording indoors or outdoors—only the conditions vary.

As mentioned earlier, from a recording standpoint, it's best to have the microphone close to your subject. But from the pictorial viewpoint you should try to avoid placing the mike so close to the subject that it is visible and distracting.

One solution is to place the mike in a concealed location near your subject (such as behind a vase of flowers). This is usually easy when you're filming indoors. Another way is to place the mike just outside the field of view of the camera. This method is useful outdoors where there are fewer places to conceal the mike. Finding the best way to hide or position a mike can be a real challenge to your ingenuity.

When you're making movies in small rooms, or in any situation where the microphone must be relatively close to the camera, there's a possibility of picking up and recording camera noise. This would be most likely to happen during a natural pause in the sound present at the scene, at which time the automatic gain control might pick up the operating noise of even the quietest camera and boost the sound to a distracting level.

KODAK EKTASOUND Movie Cameras are supplied with an alternate microphone receptacle that reduces the sound pickup by 10 decibels; so you have a choice of a full or a decreased amplifier sensitivity. It's a good idea to use the alternate receptacle (marked REDUCED) under any conditions that might accentuate camera noise. Through experimentation and personal experience you may discover additional situations that you feel warrant the use of this receptacle.

It's a good idea to stay away from flat, hard surfaces, if possible. Sound bouncing off such surfaces is usually distorted and therefore can be disturbing to the audience when it is recorded and then played back. Avoid laying the microphone on tables, counters, desks, or appliances. Even if you use a microphone stand, it's helpful to place substantial padding under and around it. (Use a towel, blanket, pillow, etc.) Inside, try to use rooms that contain sound-absorbing materials, such as curtains, drapes, carpeting, and padded furniture. If the windows do have drapes, it's a good idea to close them. Outside, keep a reasonable distance from buildings if you can. Stay out in the open or shoot in areas that are surrounded by bushes and trees. They're great sound absorbers!

Avoid hand-holding the mike. If it must be hand-held, use a firm, steady grip. Don't move your fingers over the mike or wire surfaces, and don't twist or bend the wires. Such movements are picked up and magnified tremendously in the recording. Wrapping the microphone in soft polyurethane packing material can be effective in reducing handling noises.

The sound quality of your outdoor movies can be degraded by wind hitting the microphone. You may have heard someone blow into a mike on a public-address system to see whether it was working. Wind produces the same disruptive sound — a muffled

roar. It's a good idea to place the mike in a protective tube such as that provided with the KODAK EKTASOUND Movie-Making Case whenever you take outdoor movies. The end of the tube is covered with a porous plastic foam that lets in the sound but minimizes the generation of noise created by wind rushing over the microphone. In addition, the tube will provide some protection for the mike if it is dropped. If a tube is not available, cover the mike with a handkerchief or a knitted mitten. As a last resort, put it in your pocket. Even the slightest breeze can be troublesome.

Try to keep your subjects from exhibiting nervous habits, such as snapping or drumming their fingers, clearing their throats frequently, snapping a lighter open and closed, or tapping two objects together. Such noises can detract from your sound recording.

If possible, avoid having more than one person talking at a time. Otherwise, the recording will be a jumble of sound.

# LET'S MAKE SOUND MOVIES

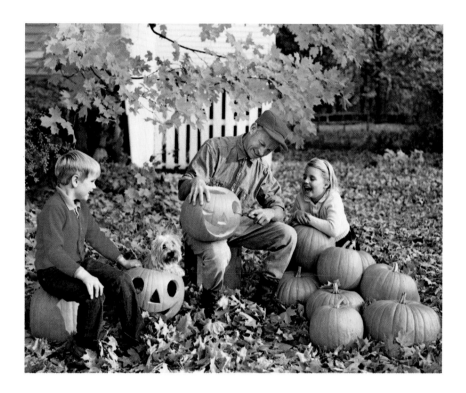

Now that you're familiar with your sound movie camera, let's make good sound movies. What makes a sound movie good? Why sound, naturally! Right? Well, only partially right. Adding sound to your movies is *only a way of enhancing your movies.*

While it's true that sound will pep up a silent movie that has a few technical faults, *taking good pictures is still the most important part of moviemaking.* Have you ever been watching television when the picture was lost but the sound stayed on? Not very interesting, was it? The visual effect is the most important element in your movies; sound is used to lend added meaning to, and reinforce, the action! Good pictures can get by reasonably well without the sound. So good sound movies are really a wedding of two very important elements— picture *and* sound! The secret of good sound movies is to make the two complement each other so that the combination is immensely better than either element by itself.

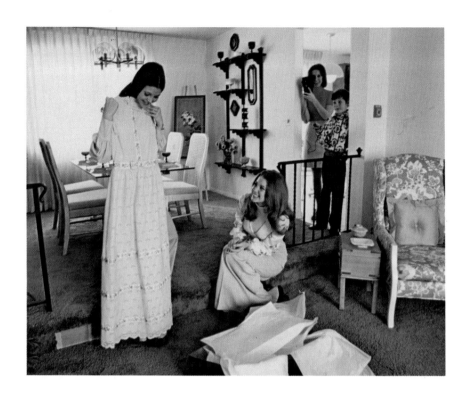

## Good Sound Movies
## Are Interesting

### Sound Movies Show Action
### and Utilize Sound

Sound movies have built-in interest because they're realistic. The subjects move and talk, just as they do in real life. But there are some things you can do to make your sound movies even more interesting. Include people—people who are moving about, engaging in natural activities, and communicating with others around them. Take a relatively simple situation and film it in an interesting way. For instance, taking movies of your teen-age daughter and her girl friend sitting on the couch and staring speechlessly at the camera is not picturing a natural activity (at least, not for most teen-age girls). However, if you stood in the doorway and made movies as your daughter showed her girl friend her new dress and they made plans for the *big* dance, chances are they wouldn't even notice you. (That's the beauty of existing-light pictures indoors.) Their excitement and happy chatter would be captured on film and become more treasured with the passing of time.

You can apply this theory to all your movies, whether they're of everyday events or special occasions. *Show your subjects moving around, talking, and acting naturally.*

## Sound Movies Tell a Story

If you photograph an event just as it happens, chances are you've made a movie story. This is especially true of sound movies, since *sound* as well as *picture* is recorded, filling in gaps left by the picture alone. You've no doubt heard the expression "One picture is worth a thousand words!" Since pictures by themselves can be interpreted in many ways, it might also be said that just a few properly expressed words in the right place can often clarify a pictured situation.

The most effective movie stories are planned in advance. If you know that something is about to happen that would make a good movie, give a little thought to some of the story possibilities. Do a little preplanning and try to determine ways in which you can control the circumstances and the outcome of the story. *Just remember—have your camera available when a good movie-making opportunity exists or your once-in-a-lifetime chance may be gone forever! Think and plan ahead!*

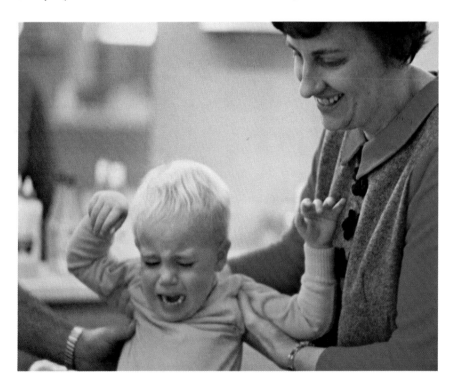

Let's suppose that little Bobby is due for a much needed haircut and you know that this isn't his favorite pastime—in fact, he usually puts up quite a fuss. Is a bell ringing in your head? You're right—what a golden opportunity! You'll laugh in later years at all the commotion over what has become a commonplace event! Have that sound movie camera ready. Make movies of each stage of the proceedings, from the time the barber calls Bobby for his turn until he's let out of the chair. These are the precious moments that, once gone, can never be recaptured!

You can make movie stories of any event. Your Christmas movie can begin with the family shopping for a tree and proceed through the removal of the decorations when the holiday season is over. Movies of your daughter's birthday party can begin with putting up the decorations and end with her playing with some of the toys she has received as gifts.

Remember, the everyday events make good stories, such as Mom bathing the baby, your daughter telling a story to her doll, and Dad helping Jimmy develop his skill with tools for a Cub Scout project. These activities will live on and become more enjoyable with the passage of time.

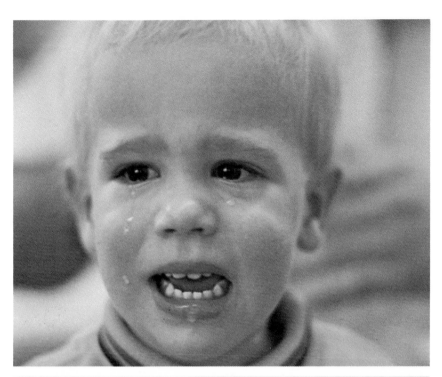

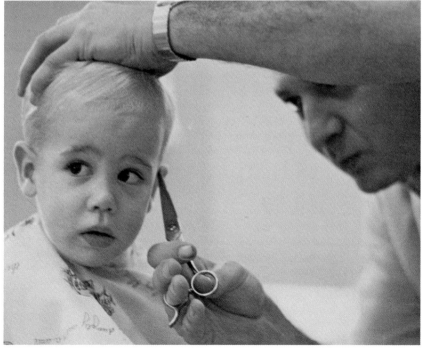

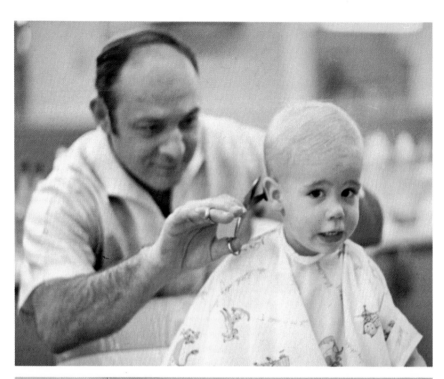

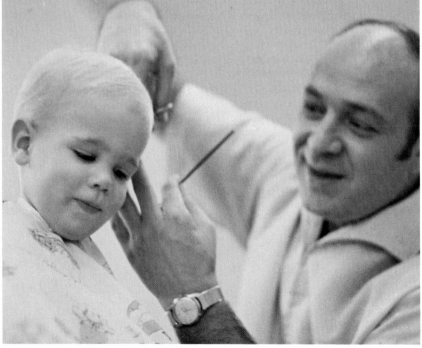

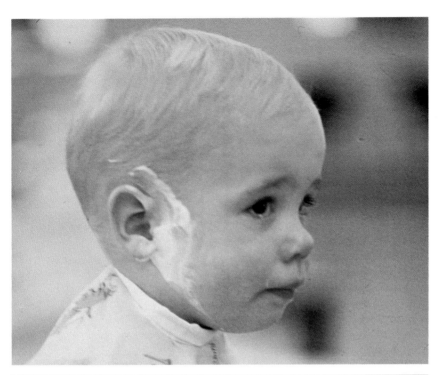

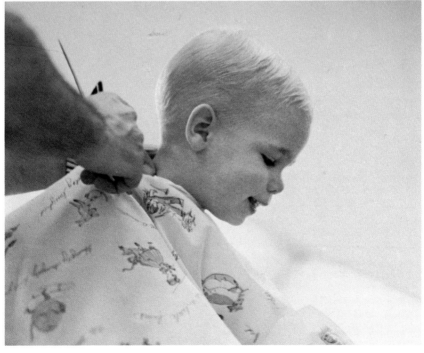

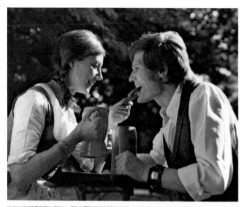

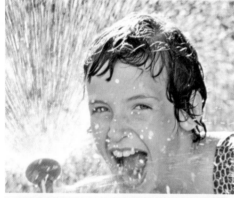

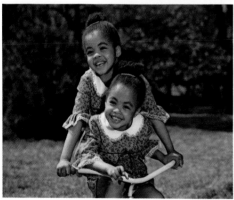

## Variety—the Spice of Movies

Changing the *subject distance,* the *viewpoint,* and the *length of the scenes* helps keep your movies interesting and your audience alert.

Changing viewpoint and changing subject distance go hand in hand. A continuous long shot from about 20 feet away will lack detail and interest, and probably eventually put your audience to sleep. On the other hand, if you "set the scene" with your long shot, move in for a medium-distance shot, change your position or angle for another medium shot, and then move in for some close-ups at various angles, the changing viewpoint will make your movies more interesting and reduce the possibility of monotony for your audience.

*Most people don't take enough close-ups!* Take another look at the haircut sequence. Notice how the photographer varied the distances and angles. Just think how much less interesting this series would have been if everything had been shot from the same position.

Sometimes when you're making fast-paced spontaneous movies you won't have time to move in and out, changing camera distances and angles. In such instances, a camera with a zoom lens is helpful. You can change the composition, and to some extent the viewing angle, without changing your camera-to-subject distance too greatly.

By now you have the idea. Move in, move out, aim your camera up, aim it down, film from the front *and* the side (even the back, if it's from a high angle or is important to the story). This

will liven up any movie sequence.

Moving in, out, and around your subject can be a little tricky with sound movies since you must consider microphone placement. It would probably be best to consider all of your shots beforehand and conceal the mike and cord where it won't be in your way. On some long-distance shots you might need an extension cord for your mike. The KODAK EKTASOUND Microphone Extension Cord, 15-foot, is available from your photo dealer for use with KODAK EKTASOUND Movie Cameras.

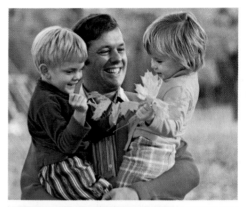

Just as you should vary the distance and the viewpoint, it's a good idea to vary the scene length too. How long should a scene be? Only long enough to show and tell what is intended! Anything beyond that is a waste of time and film. One of the biggest mistakes you can make as a movie-maker is to include unnecessary footage in your movies or leave it in once you realize it doesn't do a thing for your story. Leave it out, or edit it out! Your movie will seem more professional.

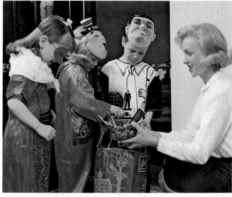

Adding sound can make your scenes either longer or shorter. Whereas silent movies take substantial time to set the scene and deliver a message, insertion of a few words in a sound movie can quickly fill in details and let you shorten the scene considerably. Some scenes may be quite lengthy if a long dialogue is necessary to put a point across. So whether a scene is long, medium, or short depends strictly on your needs. These you must judge for yourself. Here's where a little preplanning can be a big help.

Bright sunshine plus bright colors equal brilliant, colorful movies.

If your subjects aren't wearing colorful clothing, surround them with color.

Overcast or hazy days are good days for making close-up movies of people.

Colorful clothing is especially important for brightening up movies made on overcast days.

## Good Sound Movies Are Colorful

You can get the most colorful sound movies by combining bright subjects with good lighting and correct exposure. Obviously, bright, colorful subjects make bright, colorful movies. Many times you can make sure your subjects are richly colored by asking the people in your movies to wear their most vivid clothes. Clothing such as red sweaters and yellow skirts can really brighten up a movie.

Colorful subjects look their best in bright sunlight; but that doesn't mean you should give up making movies on overcast days. In fact, vivid colors are *more* important on cloudy days to keep your movies from looking dull. Colors become softer and more pastel, shadows disappear, and people aren't squinting; so overcast days can be good days for close-up movies of people.

If you must pan, follow the "rules" of panning so that you'll have a steady, sharp movie.

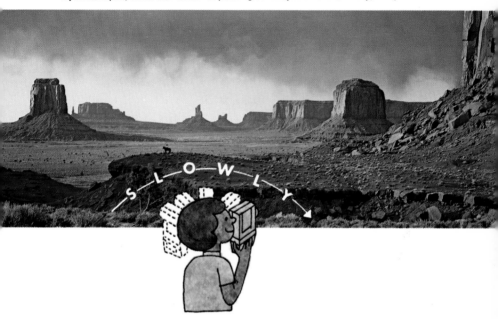

## Good Sound Movies Are Sharp

Your sound movies will be sharp when you hold your camera steady, keep the camera lens clean, and focus properly (if your camera has a focusing lens).

### Steady Camera

Your movie camera takes a series of separate still pictures that give the appearance of motion when they're projected. For these pictures to appear sharp, you must hold your camera steady. If your camera jiggles, the pictures will be blurred and your projected movie will look jumpy and unsharp.

Tripods are ideal for holding your movie camera steady; but they're not ideal for fitting into suitcases or picnic baskets. The next best thing to a tripod is a unipod (similar to one telescoping leg of a tripod). A unipod is lightweight, compact, and flexible to use. Primarily, it provides vertical support by bearing the weight of the camera (the main source of unsteadiness). If you don't have a tripod or a unipod, try bracing your camera against a wall or on a table or other firm support. The next best thing is a very steady you! Plant your feet firmly and slightly apart, brace the camera firmly against your face, keep your upper arms against your sides, and film with as little camera movement as possible.

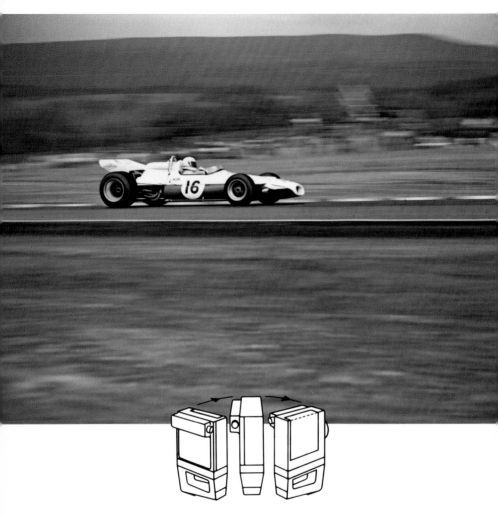

Follow a moving subject by keeping it centered
in your camera viewfinder. The subject will be sharp,
the background blurred.

Sometimes you'll want to make a "pan" shot. That's a scene in which you slowly swing the camera through an arc while you're filming. The urge to pan usually hits you when you're faced with a scenic view that's too big to be included in one straight-on shot. When you run into a situation where you feel you must pan, do it from the most important area to the least important area of the scene, and do it like this:

- First, film several seconds of the main part of the scene without moving the camera.

- Then move the camera s-l-o-w-l-y to take in the rest of the scene.

- Finish by holding the camera still on the last view for a few seconds.

If you pan too fast, your pictures will be blurred. Steadiness is important in panning, too. Use a tripod or unipod if you have one; if you don't, hold the camera firmly and pivot your body at the hips.

Sometimes it is necessary to pan to follow a moving object. In this type of pan, you keep the moving subject centered in the viewfinder so the subject remains sharp and the background becomes blurred.

Generally, for best results, the subject should move around within the scene, and the camera should remain still. Keep panning to a minimum; use only in wide, expansive scenes or with subjects travelling across a large area.

## Clean Lens

For bright, sparkling pictures, your camera lens must be clean. Lenses gradually become dirty from such things as fingerprints and dust. A movie made through a dirty lens will look hazy, like a scene viewed through a very dirty window. To clean your lens, first blow away any grit or dust, or use a camel's-hair brush. Then gently wipe the surface of the lens with a clean, soft, lintless cloth or KODAK Lens Cleaning Paper. If the lens is *very* dirty, a few drops of KODAK Lens Cleaner on the paper will have the lens sparkling in a jiffy.

## Focus

With movie cameras that have a fixed-focus lens, make sure you don't make movies of subjects closer than the distance recommended in the camera manual, unless you use a close-up lens. If your lens has a focusing scale, be sure to set it for the camera-to-subject distance. For a camera that has a built-in rangefinder, use the procedure outlined in the instruction manual.

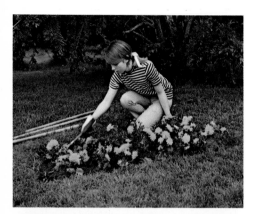

A slight focus error with a zoom lens set at the wide-angle position can become more apparent if you zoom to the telephoto position for a close-up shot.

### Using a Zoom Lens

In recent years, zoom lenses have become very popular because they combine wide-angle, normal, and telephoto lenses all in one. Just by adjusting the zoom lever or knob, you can take pictures in a complete range from wide angle to telephoto.

It's especially important to focus accurately when you're going to use a zoom lens. The distance range between the nearest and farthest subjects in sharp focus (depth of field) is much greater with the lens set at its wide-angle position than it is with the lens set at telephoto. Depth of field will compensate for small errors in focus with the lens set at wide angle; however, even the smallest focus error can be a major problem if the lens is subsequently zoomed to the telephoto position. So accurate focusing is extremely important if there is any chance that you will be using your zoom lens in the telephoto position.

A zoom lens also lets you zoom in toward the subject or away from it at the same time that you're taking the pictures. This can be very effective *occasionally;* but if you do it too much (it's a great temptation at first), you can make it uncomfortable for those viewing your movies—especially if they happen to be subject to motion sickness. The real advantage of a zoom lens is that it lets you frame your subject in the viewfinder just as you want it *before* you start filming.

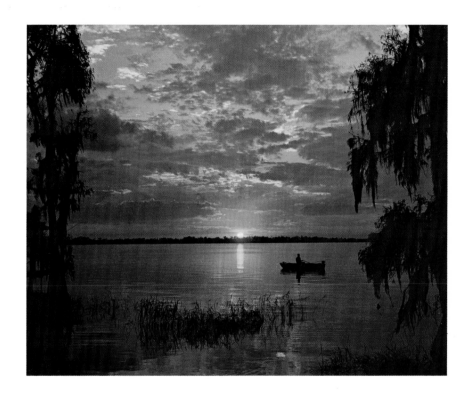

## Some Special Subjects

You can add greater interest to your movies by including some footage of unusual or especially colorful and interesting subjects. Here are just a few ideas.

### Sunsets

Sunsets are beautiful subjects for color movies, and they're as easy to film as "routine" subjects with the automatic exposure control on your camera. Just aim the camera and expose your movies. While you're at it, don't ignore—

## Sunrises

Because they're not as frequent as beautiful sunsets, most people don't realize how spectacular a sunrise can be. (Or perhaps it's because more people are up for sunsets than sunrises!) The morning after a rainstorm, the middle of an oppressively hot and humid spell, or the aftermath of an ice storm with a coat of ice over everything can provide some unusual, interesting, and colorful sunrise movies. (You say you don't have ice storms? Just thank your lucky stars, and take movies of the sunrise through those swaying palms!) Anytime you get up early, take a peek outside to the east. You might get a pleasant surprise *and* some good movies!

When you take pictures of sunsets or sunrises try to include a moving object in the foreground, such as a person, a waving bush or tree, or a boat. It will appear as a silhouette and add interest to your movie.

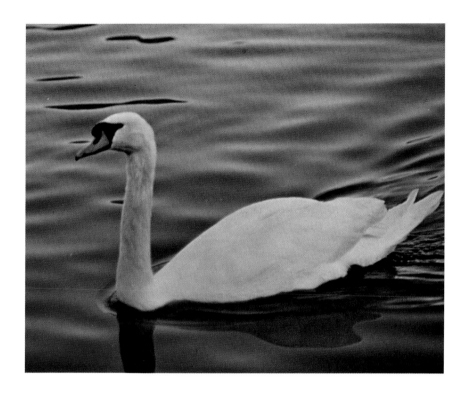

### Extreme Close-Ups

You can be almost sure of a few "ohs" and "ahs" from your audience if you include some extreme close-ups in your movies. You'll probably get a little excited, too, the first time that you see the image of a butterfly or a swaying flower filling your screen. There's something thrilling and compelling about seeing an extremely close-up view of a pair of cuddly puppies, a lovely swan, or a rose. (For that "fresh morning-dew" look, you can spray the flower with water from an atomizer.)

With an EKTASOUND 140, 150, or 160 Movie Camera and KODAK EKTACHROME 160 Sound Movie Film in bright sunlight, you can get as close as 14 inches to your subject. In many cases, this will be more than adequate; however, for extreme close-ups of small subjects, you'll need a close-up lens. These lenses slip over the regular lens of your movie camera. They are available from your photo dealer in different strengths, or powers, such as +1, +2, and +3 diopters. The higher the number, the closer

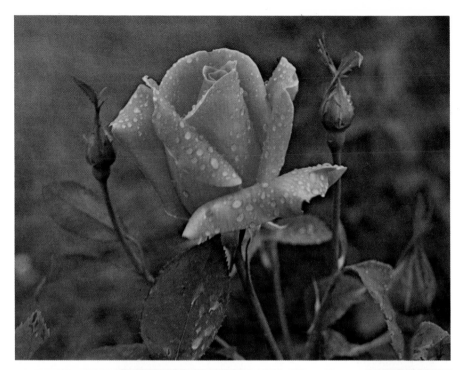

you can get to your subject. Instructions, usually furnished with the lens, tell you the lens-to-subject distance you should use and the size of the area that will be covered. A three lens set will give you a wide choice of area sizes to accommodate subjects of various dimensions.

The EKTASOUND 130 Camera requires a 57 mm, Series 8, slip-on adapter ring for close-up lenses. If you have an EKTASOUND 140, 150, or 160 Camera, you'll need a 47 mm, Series 7, slip-on adapter ring.

To get sharp pictures, you must measure the subject distance carefully when you take close-up movies. Also, since the viewfinder and the lens are slightly separated, the viewfinder loses its usefulness because it doesn't "see" the same area as the lens at close distances. Good news! It takes only a few minutes to make a cardboard measuring device that will quickly establish the subject distance and indicate the width of the area that will be in your movie.

The cardboard stiffener that laundries put in men's shirts is ideal for your measuring device. Consult the instructions for your close-up lens and determine the subject distance necessary to give you an area large enough to photograph your subject. Then cut the cardboard as shown in the drawing and inscribe a line down the center. To make close-up movies—

A Subject distance

B Width of the area you will photograph when subject is at distance "A".

• Hold the center line on the card up to the center of the close-up lens, with the card projecting straight out from the camera.

• Line up your subject until it touches the end of the card and fits within the width of the card.

• Remove the card and take your close-up movies.

When you make extreme close-up movies, with many cameras the viewfinder doesn't show exactly what will be in the movie because the viewfinder is located slightly higher than the lens or to one side of it. Compensate for this by tilting the camera slightly in the direction of the viewfinder, or make a simple cardboard measuring device.

Let's face it—subjects such as sunrises, flowers, nature subjects, tabletops, and other tranquil scenes are not normally bursting with sound. Not all movie subjects lend themselves well to sound. So, when you have sound film in the camera and don't want to pass up an interesting scene, what do you do? You might provide voice commentary, giving interesting facts about the subject matter; or you could just leave the microphone unplugged and dub in suitable commentary or background music later. Whatever you do, don't let lack of sound stop you from taking pictures you want.

Keep one thing in mind—*just because you have a sound stripe on your film, you don't have to fill every second of screen time with sound.* You may be better off to leave a silent interlude or fill in with background music, rather than insert sound just for the sake of having sound. If it doesn't add anything to your movie, leave it out.

## Sound Movies from Your Television Set

There may be times when you'll want to photograph a special event appearing on television.* This is a relatively easy procedure and the results can be quite acceptable.

The "flicker" or "banding effect" evident when TV pictures are photographed with most movie cameras is noticeably reduced with existing-light cameras that feature extra-large shutter openings, such as KODAK EKTASOUND Movie Cameras. Sometimes, quite coincidentally, the TV set and camera synchronize with each other and flicker is almost nonexistent.

Whether your TV set is color or black-and-white, there is very little difference in the quality of the results you'll obtain (with a given film) by using the following methods. All information applies to both black-and-white and color sets.

**Films.** You will obtain the best sharpness and exposure with an existing-light camera, such as the KODAK EKTASOUND Movie Camera, by using KODACHROME 40 Sound Movie Film (Type A). The speed of this film appears to be just right for photographing television images.

If you use the much faster KODAK EKTACHROME 160 Sound Movie Film (Type A), good exposure requires a little extra effort. At the minimum recommended camera-to-subject distance the automatic exposure-control system "sees" the dark area surround-

*Many television programs are copyrighted. Eastman Kodak Company undertakes no responsibility concerning any copyright matters which may be involved in photographing television images. The mere taking of pictures of a television program might be deemed a violation of the copyright, and complete responsibility for complying with the copyright requirements must remain with the person taking the photograph.

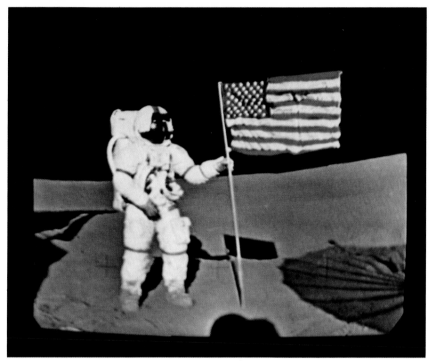

Special events shown on television lend themselves especially well to sound movies.*
You can get good results from using either KODACHROME 40 Sound Movie Film (Type A) or
KODAK EKTACHROME 160 Sound Movie Film (Type A). Photo courtesy of NASA.

ing the brighter area of the TV screen. This has a tendency to fool the exposure control which causes the lens diaphragm to open wider than necessary, resulting in overexposure and a somewhat washed-out picture. It's usually necessary to place a neutral density (ND) filter material in front of the lens to obtain correct exposure. The most accurate way to determine the correct exposure is to run a series of tests with filters of varying densities, such as .20, .30, .40, and .50 ND. Since you're not likely to have access to all these filters, you'll find that a .30 ND filter will generally give satisfactory results with a properly adjusted TV set. (Model and age of your television set and adjustment of its brightness and contrast are all vari-

ables that can affect your exposure.) Neutral density filters are available in gelatin squares or in glass. You can obtain a KODAK WRATTEN Neutral Density Filter, No. 96 (Gelatin Film), in a 2- or 3-inch square from many photo dealers.

Another way to solve the problem of overexposure with EKTACHROME 160 Film is to use a close-up lens that will enable you to move the camera close enough to the TV screen so that it fills both the movie frame and the area the camera exposure control "sees." (Refer to *Extreme Close-Ups,* page 57.) In this case the automatic exposure-control system should provide acceptable exposure. See your photo dealer for additional information on close-up lenses.

**Photographing TV images.** Now that you know what to expect from the available sound films, just use the following easy steps for successful pictures from television.

- Load the camera with the film of your choice.
- Use a camera speed of 18 fps and set the filter switch for daylight exposures, "☀".
- Place the camera on a tripod or other firm support, level with the center of the TV screen and at the minimum camera-to-subject distance. The minimum distance with a KODAK EKTASOUND 130 Movie Camera is 8 feet. Movies made at the minimum distance with this camera will not fill the movie frame, even with the largest available home television screen. Minimum distance with KODAK EKTASOUND 140, 150, and 160 Cameras is about 6 feet with the lens set at the maximum telephoto position. Under such circumstances, the picture from a 23-inch TV set will fill the movie frame. Center the TV screen in the viewfinder and move the front of the camera *slightly* in the direction of the viewfinder lens to allow for the difference in position of the viewing lens and the camera lens.
- Plug the microphone into the camera. Place the mike *at least* 6 feet from the TV set. *If you don't, you may have an audible hum on your sound track when the movie is projected.*
- Adjust the controls on the TV to obtain the best possible picture. To minimize the possibility of picking up unwanted sounds, set the volume control slightly higher than you might normally set it.
- If possible, turn off all of the lights in the room to avoid distracting reflections on the face of the TV picture tube.
- You are now ready to make sound movies from your television set.

If you are using a neutral density filter with EKTACHROME 160 Film, you can hold the filter in front of the lens each time you make exposures. For frequent use, it is usually more convenient to place it in a KODAK Gelatin Filter Frame and attach it to the camera with a KODAK Gelatin Filter Frame Holder. Both are available through your photo dealer. With some cameras a step-up ring may be necessary to attach the holder to the lens.

Each 50-foot cartridge of film will provide you with approximately 3⅓ minutes of movies; so, if you want to film a complete program you will need several cartridges for each half hour. Although super 8 film cartridges permit you to change film rapidly, you can still lose a small portion of the program each time you change cartridges. So, for convenience and economy, you may want to record only the portion of the program you are especially interested in, or perhaps just the highlights.

If you do decide you want continuous coverage of an entire show, set up two cameras of the same model (if available) side-by-side. When the end-of-film indicator becomes visible in one camera start the other running simultaneously. The slight overlap in coverage will enable you to splice the film at a spot that will provide uninterrupted coverage. When you start, be sure you have fresh batteries in the cameras and keep a spare set handy.

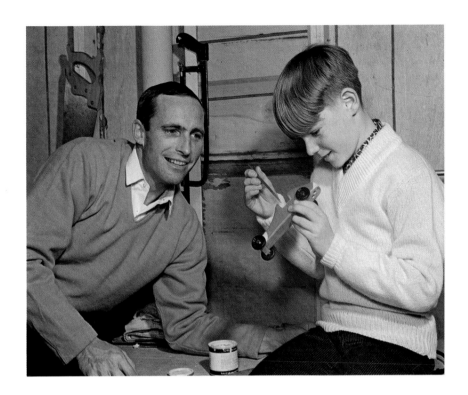

# INDOOR MOVIES

The weather is always fine for making indoor sound movies. With a KODAK EKTASOUND Movie Camera and KODAK EKTACHROME 160 Sound Movie Film (Type A) you can take existing-light pictures under most indoor lighting conditions. For those rare times when you need a little extra light for fill-in or general illumination, there are low-output movie lights available.

### Movie Lights

Even when you use the moderate speed (ASA 40) KODACHROME 40 Sound Movie Film (Type A) in your EKTASOUND Camera, you will be able to take pictures with less light than many other movie cameras require. However, when you do need supplementary lighting, you'll probably need a light with a relatively high output, such as a 650-watt sealed-beam movie light. Most new movie lights made for mounting on top of the camera, automatically move the Type A conversion filter into the correct position when inserted in the movie-light slot. Your photo dealer can give you complete information and help you select a suitable movie light.

> **WARNING:** For the safety and comfort of your subjects, read the manufacturer's instructions carefully before using any movie light.

## Existing-Light Movies

The most natural way to make movies is by existing light, using only the lighting that happens to be on the scene. This includes the light from table and floor lamps, ceiling fixtures, fluorescent lamps, spotlights, neon signs, windows, skylights, candles, fireplaces, etc. In other words, existing light is any type of light found indoors, or outdoors at twilight and after dark. Existing light is not normally as bright as most outdoor daylight conditions.

Movies made this way are very realistic, and it's easier for your subjects to relax and be themselves. It's also more fun to make movies this way, because you don't have to bother with movie lights.

When you want to use KODAK EKTACHROME 160 Sound Movie Film to make movies of subjects in existing tungsten light (regular light bulbs) or firelight, you should move the filter switch on your camera to "☾." To film subjects in existing daylight indoors, under fluorescent illumination, mercury-vapor lighting, or carbon-arc spotlights, set the filter switch to "☀". Sometimes there may be a mixture of light from different sources. In such situations, set the filter switch for the predominant light source (if there's any doubt, use "☀"). If you use the recommended filter settings you should get the most lifelike color rendition for the lighting condition.

If you are using KODACHROME 40 Sound Movie Film in your camera, you will be able to take properly exposed existing-light movies of brightly lighted subjects only, such as floodlighted or spotlighted events. With less illumination you will need to use a movie light. Filter-switch recommendations are the same as for EKTACHROME 160 Sound Movie Film.

In home interiors, unless there's a lot of sunlight coming in, be sure you turn on all the available lights in the room to make the lighting as bright and even as possible. If you need more light, place your subject near a bright lamp, or near a window in daytime. Avoid camera angles that include a bright lamp or window directly behind your subject. Such a bright light source could mislead the automatic exposure control in your camera and cause underexposure of the subject.

When using EKTACHROME 160 Film, you can take movies as long as the low-light signal in the camera doesn't indicate that the lighting is too dim for full exposure. Even when the low-light signal does show in the viewfinder, it's often worthwhile to take movies anyway, as long as you can see the subject! Your movies will appear dark; but then, so did the subject.

Many movie cameras with through-the-lens viewing and metering do not let all the light pass through the lens to expose the film. Some of the light is diverted through the viewfinder and some is used for the exposure control. This loss of light may make a difference in exposure of as much as one stop. An $f/1.9$ rated lens, for example, may have a maximum effective lens opening of $f/2.8$. As a result, cameras with these characteristics may not let you take movies in as dim lighting as you might expect. This is not true of KODAK EKTASOUND Movie Cameras (or KODAK XL Cameras) which have been designed to let nearly all the light that enters the lens reach the film.

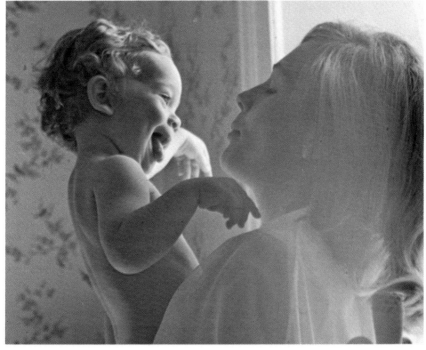

A good time to take night movies is just after sundown, when there's still some color left in the sky.

# EXISTING-LIGHT MOVIES OUTDOORS AT NIGHT

After-dark movies can add an unusual and colorful touch to your movie showings, and they're easy to make. Existing-light movie-making lets you film a variety of interesting night subjects, such as city street scenes, lighted statues and fountains, lighted signs, Christmas displays, sporting events, amusement parks, and fireworks. Fireworks displays have always had a fascination for young and old alike—just think how much more you'll be able to enjoy them when you *hear* as well as see them burst in midair.

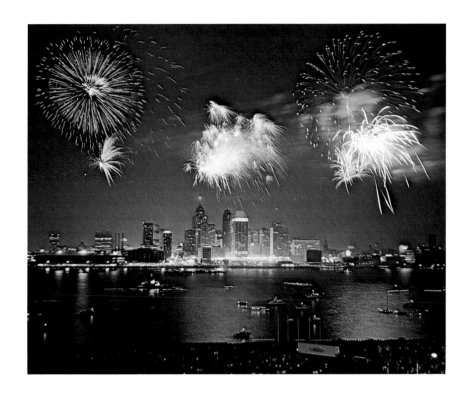

And what an improvement the sounds of the midway will make in carnival and amusement-park scenes.

Since the existing lighting outdoors at night is so much dimmer than daylight, it's best to use EKTACHROME 160 Sound Movie Film (Type A). But if your camera is already loaded with KODACHROME 40 Sound Movie Film (Type A), you can still film *most brightly lighted scenes,* such as brightly lighted sporting events, fireworks, theater districts, and campfires.

For most night scenes, Type A film produces more satisfactory results with the filter switch set at "⊸⊙". Colors look more natural and the effective film speed is not reduced by a filter. Some subjects, such as outdoor sporting events, may be lighted by mercury-vapor lamps, which have a slightly bluish-green appearance. With this kind of lighting, the colors in your movies will look better if you set the filter switch at "☀". The filter absorbs light and reduces the effective speed of the film; so using the filter is practical only when the low-

light signal indicates that the light is bright enough for correct exposure with the filter in front of the lens. If the low-light signal comes on in such a situation, it's usually better to remove the filter for increased exposure latitude and accept the resulting blue-green color balance.

The EKTASOUND Camera and EKTACHROME 160 Sound Movie Film give you outstanding versatility for outdoor movie-making at night. The features of the camera and the speed of the film allow you to photograph almost anything you can see. Because the automatic exposure control on your camera can be misled when large areas of darkness surround your subject, you may see the low-light indicator in the viewfinder when you really have enough light for acceptable exposures. If having the movies is more important to you than the possible loss of a few feet of film, take your pictures. Chances are they will turn out quite well, even though a scene which looked dark when you took it will probably look dark in the movies. An extraordinary camera and film still can't turn darkness into light!

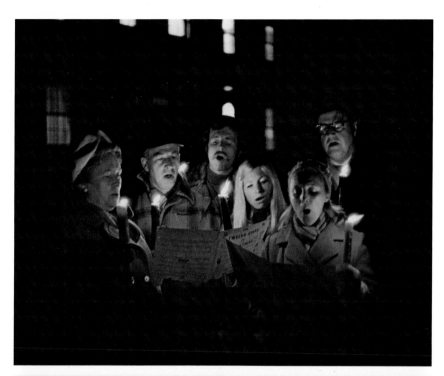

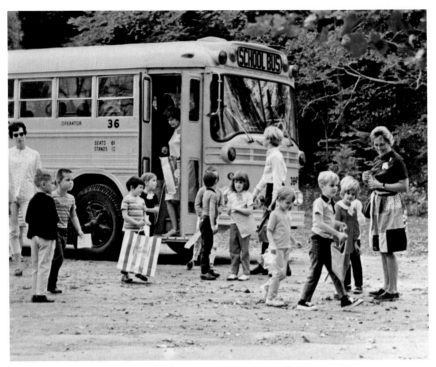

Events such as a kindergarten autumn nature outing can provide colorful and interesting subject matter for a movie.

# POSTRECORDED SOUND

Postrecorded sound is sound that is recorded on the film after the movie is completed. It can be used to improve your prestriped camera-original movies or to add sound to your silent movies after they have had a sound stripe applied (see "Silent Films," page 20). If you have a projector that is capable of reproducing *and* recording sound, such as the KODAK EKTASOUND 245B Movie Projector, it is a relatively simple procedure and can be accomplished with a minimum of additional equipment.

With postrecording techniques you usually have better control over recording procedures. For instance, you can record music only, commentary only, alternate commentary and music, or commentary *and* music together (see *"Sound-On-Sound,"* page 82).

You have a choice of two methods of postrecording—through the use of prerecorded sound transferred electronically to the sound stripe from a tape recorder or record player, or through a microphone (live).

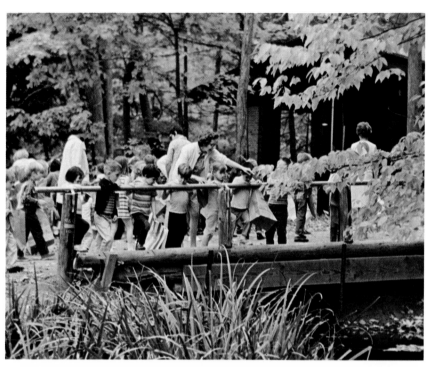

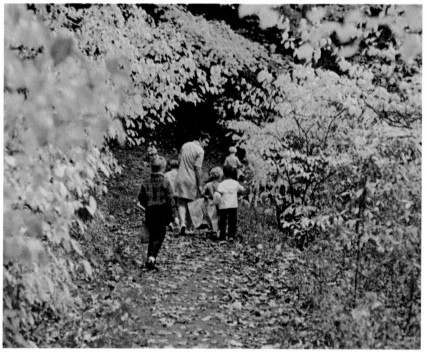

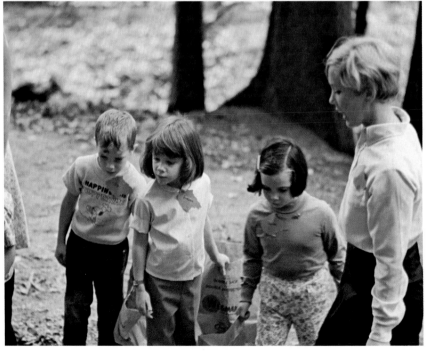

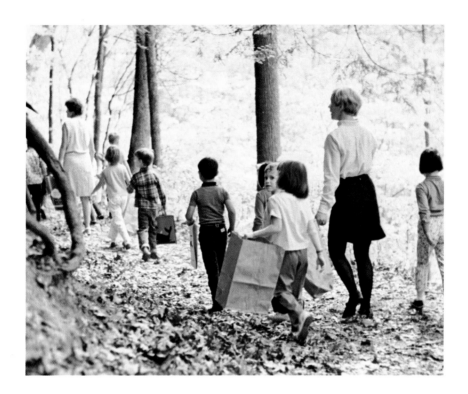

## Electronic Transfer

This method is used primarily for placing background music on your sound stripe; however, sometimes you may want to record both background music and commentary on tape first and then transfer them to the sound track. Electronic transfer, when used with equipment of suitable quality, usually provides the best sound and isn't affected by extraneous noise.

The first requirement for electronic transfer is that your projector must have an input jack for picking up and recording the sound, as the KODAK EKTASOUND 245B Projector does. Then, there are two ways in which you can make the transfer:

• Connect the output jack from the amplifier on the tape recorder or record player to the input jack on the projector. This requires a "patch cord" with a phono plug at each end.

• If your tape recorder or record player doesn't have an output jack, you can obtain an inexpensive jack from a radio supply house and connect it to the speaker terminals of your sound system. The connection can be made *permanently* by soldering the cord leads to the terminals or *temporarily* by using "alligator clips." In either case, it takes only a few minutes, and almost anyone can do it. Then, all that remains is to obtain the correct patch cord. It's possible to exceed the range of the automatic gain control on your projector when recording in this manner; so you should set the gain manually while observing the VU meter (see your projector instruction manual for detailed instructions on the correct procedure).

## Live Recording

Basically, there isn't much difference between in-projector and in-camera "live" recording. You must observe proper microphone placement and handling, avoid unwanted extraneous noise, and use the correct recording procedure as described in your instruction manual.

### Eliminating Extraneous Noise

Your biggest enemy is projector noise. When you record music, projector noise will be minimized if the mike is fairly close to the loudspeaker, the volume high enough, and the projector far enough away. The lower inherent volume and natural pauses of commentary are more easily penetrated by noise from the projector. There are several ways to minimize the possibility of picking up projector noise, such as:

- Use a directional microphone, such as the KODAK Directional Microphone, that will exclude some of the extraneous noise.

- Always get the mike as close to the sound source (minimum, 1 foot) and as far from the projector as possible. If the mike cord isn't long enough, use a mike extension cord.

- Record in a room that has natural sound deadeners, such as drapes, carpeting, and padded furniture.

- Place padded screens or furniture around the projector or microphone—anything to isolate one from the other more effectively.

An easy and inexpensive way to make a sound baffle is to cut the flaps off a cardboard box (about the size used for canned foods) and line the inside with anything that will absorb sound. The thicker the padding the better. Carpet scraps, unused throw

Your vacation movies can be enhanced by simple (yet effective) scenes such as this, showing the children experiencing their first taste of a tree-ripened orange.

74

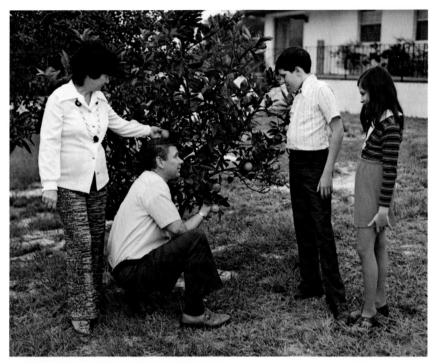

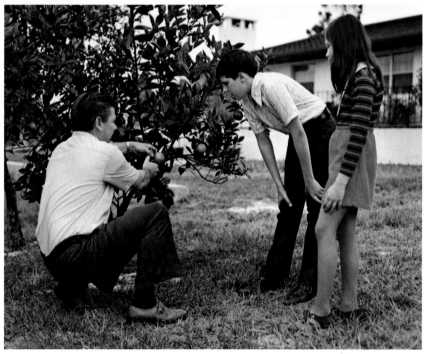

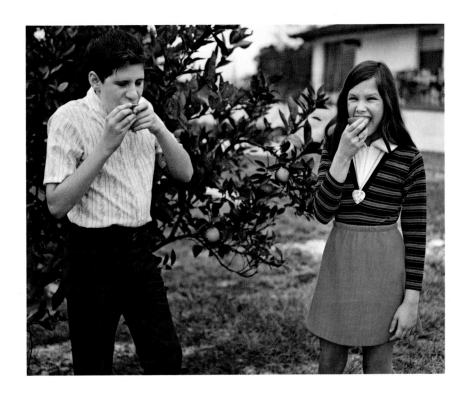

rugs or drapery material, cork tile, and polyurethane foam are all good materials. Insert the mike through a hole in the bottom of the box and place the box with the open end near and facing the source of sound (loudspeaker or narrator) and the bottom toward the projector.

- Project from one room to another, placing the projector and microphone in separate rooms. The walls on either side of the doorway will act as baffles and prevent some of the noise from passing through.

After you decide on the best means to minimize the possibility of projector noise, make a test recording of some commentary for about 15 seconds. Play back the recording at high volume to determine if any objectionable projector noise is present. If not, you should be able to record almost anything (even quieter music passages) without any problem.

Here are some additional tips for avoiding unwanted noises that might detract from your recording. Isolate the recording room as completely as possible. Make sure all windows and doors are closed. Close any drapes in the room. Set the thermostat so that the furnace or air conditioner are less likely to go on (lower for a furnace, higher for an air conditioner). Do your recording later in the evening, when children are in bed and everything is generally quieter. Temporarily stop any clocks that normally chime. You might even want to remove the telephone from the hook (only during actual recording and if you aren't on a party line) and wrap it in a towel to block any audible signals it might emit.

## Music

Be sure the background music you select is appropriate to the movie scenes being shown. Use light, lively music for scenes in which there is a lot of activity. Suitable "dinner music" or semiclassical music might be better for scenes with deeper moods. Listen closely to the background music used on television to get a feeling for what might be suitable in different situations.

For legal reasons, no music records or tapes should be re-recorded unless you have proper clearance, or "use rights." Recorded music for which clearance can be obtained is available from music libraries such as those listed below:

> Emil Ascher, Inc.
> 745 Fifth Avenue
> New York, New York 10022

> Capitol Production Music
> Capitol Records, Inc.
> 1750 Vine Street
> Hollywood, California 90028

> Sam Fox Film Rights Inc.
> 1540 Broadway
> New York, New York 10036

Catalogs from music libraries usually list titles, themes, moods, and the exact playing time for individual musical segments.

## Voice

A good degree of "professionalism" can be obtained if you follow these easy suggestions:

- Project the movie several times to familiarize yourself with the content of each scene.
- Time the length of each scene to determine how much material is needed.
- Write a script. If possible, make your comments last no longer than the scene (add or delete information as necessary).
- Practice your presentation until your timing is good and you're thoroughly familiar with the contents; then, make the recording.

### Alternating Voice and Music

The amount of narration necessary to supplement and clarify the action in your movies may vary considerably from scene to scene. Some sequences require little or no narration, because the pictures are self-explanatory. To explain what is happening would be a waste of time and effort. However, recording narration only as needed can leave awkward silences that are distracting. In such situations, it might be desirable to fill in with suitable music to improve the overall effect.

Usually, the easiest way to record alternate voice and music is to record each section in turn, whether voice or music, as it occurs in the movie. The selection of appropriate music and correct timing of each section are the most critical aspects of this technique.

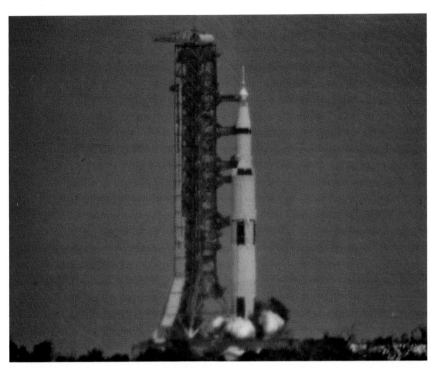

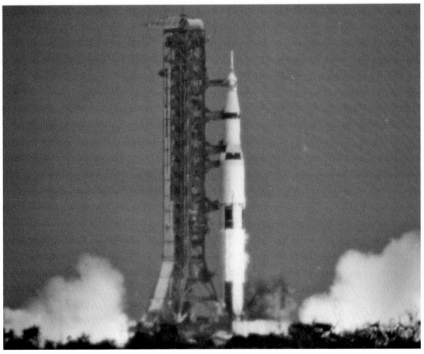

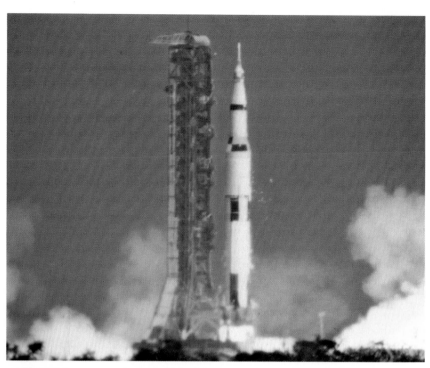

## Sound-On-Sound

Sound-on-sound, or the recording of voice *and* music simultaneously on the sound stripe, is probably a little better than alternating commentary and music. In some ways it can be a little easier too; for instance, it's easier to choose and record music that is to be played continuously in the background than music that must fill the brief gaps in the commentary.

There are a variety of ways in which you can record sound-on-sound. You can play music in the background as you narrate; or you can record music on one track of a stereo tape recorder and voice on the other track—then transfer them electronically to your sound stripe. If you record directly on a projector, such as the KODAK EKTASOUND 245B Movie Projector, you can record narration over music previously recorded on the sound stripe.

Recording music and voice at the same time seems like the easiest method of producing sound-on-sound; however, if you make a mistake in either music or voice, both must be re-recorded. Also, achieving and maintaining a good volume balance between the two is more difficult.

You'll have the most control over the recording process if you place music on one track of a stereo tape and commentary on the other, then transfer them electronically to your sound stripe. (You'll need a suitable "Y" adapter to plug the stereo output into a monaural projector input.) This eliminates the need to re-record both parts if something goes wrong with either part. Another advantage is that you can save the master tape and use it again in case of accidental erasure of the sound stripe on your film.

Some projectors have a partial erase feature that allows you to erase as much of the existing sound as desired while recording at the same time. You can usually get best results by recording the music first and then recording over the music with the narration. The position of the erase knob determines the amount of original sound that is erased and lets you control the volume balance between music and voice. With a little testing and/or practice you'll be able to determine the best erase-knob setting to obtain the effect you prefer.

When you record voice over music, you can obtain a "professional" fade effect by gradually turning the erase knob from "off" to a predetermined level (reducing the music volume), recording the narration, and then slowly moving the erase knob back to "off" to fade in the music.

Use the partial erase feature also, to record over camera-original sound; for example, the sounds of a parade or a car race. However, keep one thing in mind—*if you make any mistakes, such as erasing too much of the original sound or getting the wrong volume balance, you have no way of picking up the original sound again and correcting your error.*

## Summary

As with anything new, the recording techniques provided here require familiarization and practice to obtain the best results. They also require more than a passing acquaintance with your equipment. Read your instruction manual, use the equipment, and experiment—the results will speak for themselves.

A little imagination is all that's necessary to create "on-the-spot" titles.

## ADDING TITLES TO YOUR MOVIES

Titles can give your movies that additional quality that will raise them into the "extra-special" class. Even with sound movies, titles have a very definite purpose. They quickly and graphically tell your audience what's coming and help to make your movies more interesting.

The easiest and best way to make titles is by photographing the ready-made titles that exist all around you. You'll find them at the entrance to almost every tourist attraction, park, or public building, and at the city line of almost every city you visit. *Signs* make great titles! Historical markers, billboards, and posters are all good title material. As a rule of thumb, photograph a sign for about *twice* the length of time it takes to read it.

Whenever possible, include the date in your titles (at least the year). It will serve as a good memory-jogger later.

You can make your own titles, too, with just a little imagination and a speck of artistic ability. You can create on-the-spot titles by writing in the sand at the beach or by using colorful stones and pebbles to form the words. Another good idea is to carry along a set of self-adhering titling letters (available from many photo- or art-supply stores), placing them on the side panel of your car or other smooth surface, and photographing the titles as you need them. If you have the kind of letters that stick by static electricity or have a slightly tacky backing, there will be no harm to the surface used. This method takes only a few minutes and eliminates the need for editing-in titles later.

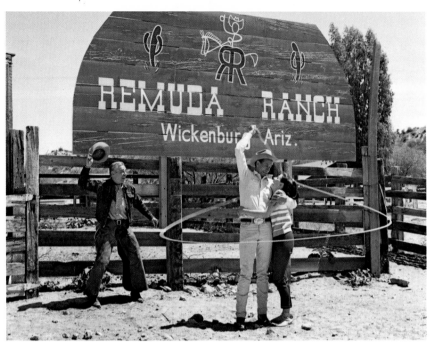

Ready-made titles are all around you.

Other ways of making "instant titles" are to photograph newspaper headlines (such as "Christmas 1974"), travel brochures, or the writing on cakes made for special occasions, such as birthdays. You can make more "formal" titles by photographing titling letters, such as described earlier, against a background of colored art paper or wood paneling.

If you want to get really fancy, you might buy a movie titler. Check with your photo dealer about one suitable for use with your camera.

## Sound with Your Titles

Making the titles as you go along is a distinct advantage when you have a sound track on the film. The addition of sound provides audio impact to enhance the visual message of your titles. The natural sounds that are present while you photograph ready-made titles are often quite suitable. However, you might also provide commentary if there isn't enough interesting sound available at the scene.

Have you ever seen a movie or slide presentation in which the speaker proceeded to read aloud the printed information provided on the screen? It's a natural temptation to do this, but it's also unnecessary and distracting to your audience; so please, resist any such urge! If you accompany a title with commentary, provide some interesting background facts on what is taking place or what your audience is about to see.

Another alternative would be to tape-record sounds that are more appropriate to the title scene and transfer them to the sound track later. Or, you might put in some interesting background music. Whatever method you choose, take advantage of the use of sound to enrich your titles!

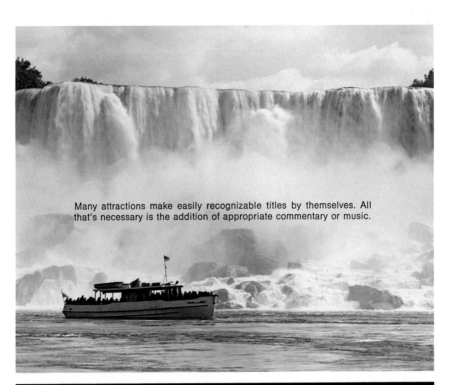

Many attractions make easily recognizable titles by themselves. All that's necessary is the addition of appropriate commentary or music.

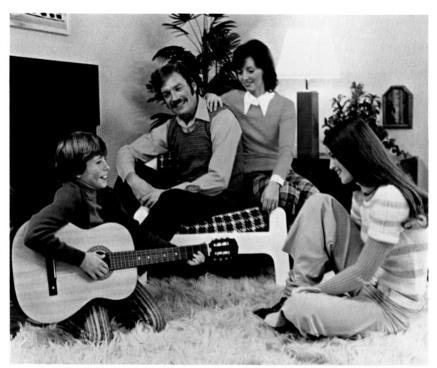
Family "togetherness" comes across especially well with sound movies.

# EDITING AND
# SPLICING YOUR
#        SOUND MOVIES

You can dramatically improve the quality of your movies by editing your processed films. To provide that finishing touch to your movies, you should remove any section that is not of good quality, such as poorly exposed or badly out-of-focus scenes. In addition, it might be necessary to rearrange the order of scenes that for any reason had to be shot out of sequence or that might improve the continuity of your movie.

After each cartridge of film is processed, the film is returned to you on a 50-foot reel. If your movie consists of several such reels of film, you can improve your presentation considerably by splicing them together on a larger reel. This is another form of editing and will result in a smoother, more pleasing show, eliminating awkward breaks in your story due to the need to change small reels frequently.

When you edit movies, you need a method of viewing the pictures to determine the correct place to cut the film. You also need a way to transport the film back and forth quickly. The best device for this purpose is a

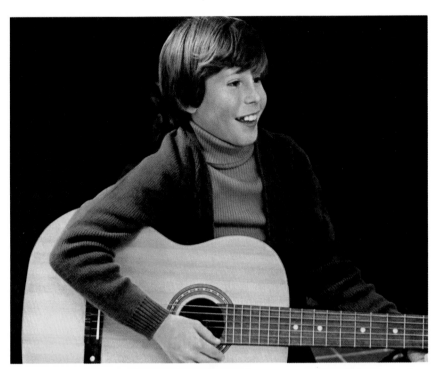

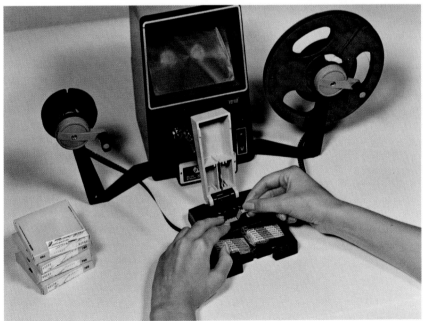

Editing and splicing are easy with the right equipment.

film editor, consisting of an action viewer, a film-transport system, and sometimes a splicing device.

When you start connecting rolls or cutting out and rearranging scenes, you must have a way to reconnect the ends of the film that you will keep. This technique is called splicing. Splicing was a bit tricky in the days when the only way to splice two pieces of film together was to scrape the emulsion from the film and use liquid film cement. Now you can use a dry splicer and pressure-sensitive film-splicing tape, such as the KODAK PRESSTAPE Universal Splicer and KODAK PRESSTAPES. Complete instructions come with the splicer. Briefly, all you do is put a piece of perfo-

rated transparent tape on each side of the film when you make the splice. The splicer trims the film for you and lines up the perforations in the tape with the perforations in the film.

There's only one slight difference between splicing silent and sound film. If the splicing tape covers the sound stripe, the quality and volume of the sound will be degraded. If you want to minimize this possibility, first place a tape on the *unstriped* side of the film. Then, trim approximately $\frac{1}{16}$ inch from the edge of the second tape (opposite the perforations) before applying it to the *striped* side of the film. Trimming the tape leaves the sound stripe uncovered for good sound reproduction and there's no appreci-

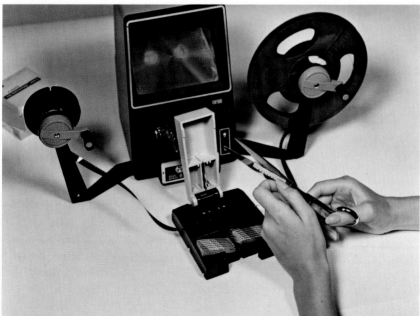

Trim approximately 1/16 inch from the PRESSTAPE to be applied to the *striped* side of the film.

able loss of strength in the splice.

By doing a little editing and splicing, you can get rid of scenes that didn't turn out exactly as you had hoped, put scenes in the order you want them, and place several small reels of film on one larger reel—all with very little time and effort.

## The Effect of Picture and Sound Separation on Splicing

You must keep in mind that the sound-recording head, in cameras such as KODAK EKTASOUND Movie Cameras, is located 18 frames ahead of the film aperture. (This is the equivalent of approximately 3 inches of film or 1 second of time.) The same separation is maintained in sound projec-

tors, so that when the movies are shown, the picture and sound are synchronized and will appear to be together.

Since the sound and the picture are separated, some unusual situations can develop when you splice rolls together and remove or rearrange the order of scenes. The most common effect is the carry-over of unrelated sound to a new scene or sometimes a brief absence of sound near a splice. Much of the time these effects are unnoticeable, but even when they are, they usually aren't objectionable since they are so brief.

You can minimize the carry-over effect by not recording the sound for the first second or two of each new scene.

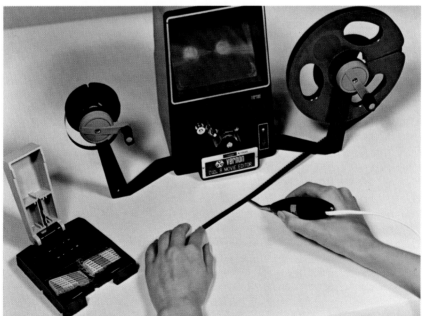

One way to erase a small portion of the sound track is with a tape-head demagnetizer.

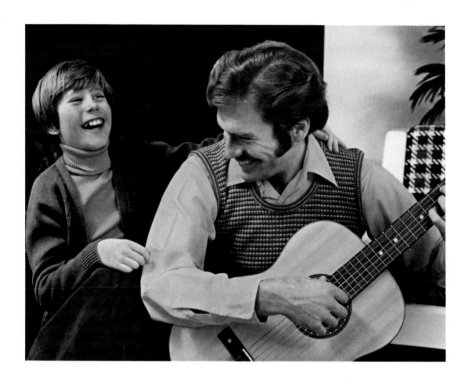

However, since this isn't always possible, you can also produce the same effect by erasing the last three inches (18 frames) of the sound track *preceding* a splice. This can be done easily with a common magnet. To avoid scratching the film, place a thin sheet of paper over the film and the sound stripe. (Remember, the sound stripe is the one on the edge of the film opposite the perforations!) Place the magnet on the paper directly over the sound stripe and move it s-l-o-w-l-y several times across the area to be erased, always starting at the same point and moving in the same direction. You can also use an electromagnet of the type available from hi-fi stores for demagnetizing the sound head on tape recorders.

Either method involves a relatively low level magnetic field, but normal caution should be used to avoid contact with the film and possible accidental erasure of the sound track. *As with any magnetic sound-recording material, this film should be kept away from strong magnetic fields, such as those created by large motors and generators.*

Whether you splice your sound movies as you would silent movies, ignoring the relatively minor effects caused by sound and picture separation, or take steps to minimize the situation is a decision you must make based on your own individual needs and desires.

# SHOWING YOUR MOVIES

Being a captive audience for the home movies made by a friend or relative has often been compared to "a fate worse than death"—sometimes with good reason. However, *good* home movies, the kind you'll be showing from now on, enhanced by available-light scenes and sound *are* entertaining. An entire new world of home entertainment is possible. Movies of picnics, vacations, special events, and even day-to-day activities will have added interest and meaning.

Aside from showing uninteresting, poor-quality movies, the worst thing you can do is provide too long a showing. Keep your shows down to an hour or less. It's better to leave your audience wanting more, than to have them uncomfortable and squirming in their seats. They'll appreciate your thoughtfulness and look forward to future showings. Here are a few more tips that will make good home movies even more enjoyable:

- Set up your projector before your audience arrives.
- To avoid a distorted image, line up your projector with the center of the screen so that you don't have to tilt the front of the projector.
- If possible, make the projected image fill the screen.
- Thread the projector and run several feet of the movie. Focus the image, make sure the frame line isn't showing, and adjust the sound volume to a comfortable listening level. Back up the film until one of the first frames of the movie is in the gate. Then, the first thing your audience will see is the start of the movie, not a glaring white screen.
- For best viewing, arrange the seating so that your audience is as close to the axis of the screen as possible.
- Make sure the room is dark enough for good viewing. Eliminate any stray light that falls on the screen.
- Place a lamp so that it's easy to reach at the beginning and end of each reel.
- If the projector power cord runs across an open area of the floor, place throw rugs over it to prevent tripping.
- Keep a spare projection lamp handy.

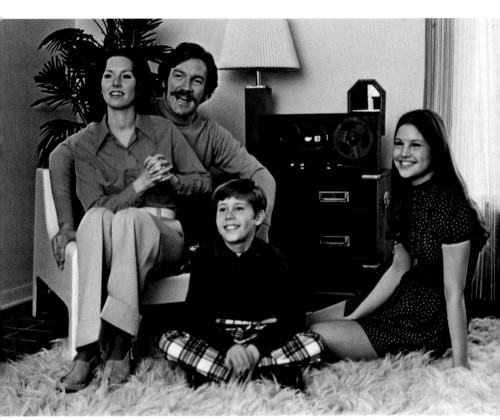

Many hours of watching and listening pleasure can be yours if you follow a few simple rules.

# CARE OF YOUR...

Keep battery and equipment contacts clean by wiping them with a rough cloth.

### Camera

Your camera doesn't require a lot of maintenance, just a little tender loving care. Treat it as the precision instrument that it is, and it should serve you well for a long time. Here are some tips that will help you keep your camera in good operating condition and also help you make better-quality movies:

- Keep the lens clean.
- Keep the inside of the camera clean. Pay particular attention to the camera gate and aperture. Dust, and perhaps film particles, can gather in these areas and scratch your film or even block part of the image from getting to the film. Follow the cleaning instructions in your camera manual. You can usually use a small rubber syringe to blow dirt from the inside of the camera, or clean it with a small soft brush.
- Use only the type of batteries the manual recommends, install them correctly, check them periodically, and keep the contacts clean. Deposits often build up on battery and camera contacts, preventing the camera from running. To avoid this, clean the contacts in the camera and the ends of the batteries frequently, even if they look clean (some deposits are invisible). Wipe them with a rough cloth.

## Film

Expose your film and have it processed before the date printed on the film carton, and always have the film processed promptly after you've taken your movies.

Store your unprocessed movie film and your processed movies where it is cool and dry. It will mean better-quality movies that keep their new look for a long time.

Store your processed movies in lighttight, dustproof cans. If your movies need cleaning, use a cleaner designed specially for movie film, such as KODAK Movie Film Cleaner (with Lubricant). The lubricant in the film cleaner helps eliminate jumpy movie projection because it allows the film to pass more easily through your projector.

## Projector

To do justice to your processed movies, keep your projector and its lens clean. *Before you start cleaning any part of your projector, make sure it's unplugged and has cooled if it's been running.*

Clean the front of the projector lens and the back if the lens is removable, by wiping the surfaces with a clean, soft, lintless cloth or KODAK Lens Cleaning Paper. See your projector manual for instructions on removing the lens.

Keep the pressure pad, aperture, and film channel of the projector gate clean. Clean the pressure pad with a damp cloth, and the film channel with a soft brush. Clean the aperture by dusting it with a soft brush or by blowing on it. The instruction manual will give you more specific instructions. When the gate is clean, there will be less chance that particles will rub off the film and accumulate into a bothersome glob that shows up on your screen, or even worse, scratches your movies.

Don't lubricate your projector unless the instruction manual tells you to. To a permanently lubricated machine, oiling can be quite harmful; to one that isn't permanently lubricated, incorrect lubrication can be equally damaging.

## ADDITIONAL INFORMATION

If you have additional questions about making sound movies, please write to our staff of photo experts at Eastman Kodak Company, Photo Information, Dept. 841, Rochester, New York 14650.

Other Kodak publications that may be of help to you are—

*KODAK SONOTRACK Coating Service,* KODAK Publication No. D-27. You can obtain a single copy free by writing to the address listed above.

*Basic Magnetic Sound Recording for Motion Pictures,* KODAK Publication No. S-27, 42 pp., $1.25, available from your photo dealer. If he cannot supply this book, order by title and code number from Eastman Kodak Company, Dept. 454, Rochester, New York 14650. Please enclose remittance, including applicable state and local sales taxes. *Prices are subject to change without notice.*